HOW TO DRAW
CUTE FOOD

This book belongs to:

..

..

HOW TO DRAW
CUTE FOOD

Angela Nguyen

STERLING CHILDREN'S BOOKS
New York

STERLING CHILDREN'S BOOKS
New York

An Imprint of Sterling Publishing Co., Inc.

STERLING CHILDREN'S BOOKS and the distinctive Sterling Children's Books logo are registered trademarks of Sterling Publishing Co., Inc.

© 2019 Quarto Publishing plc

First Sterling edition published in 2019.

ISBN 978-1-4549-3756-2

Distributed in Canada by
Sterling Publishing Co., Inc.
c/o Canadian Manda Group, 664 Annette Street, Toronto, Ontario M6S 2C8, Canada

For information about custom editions, special sales, and premium and corporate purchases, please contact Sterling Special Sales at 800-805-5489 or specialsales@sterlingpublishing.com.

Manufactured in China

Lot #:
10 9 8 7 6 5 4
12/21

sterlingpublishing.com

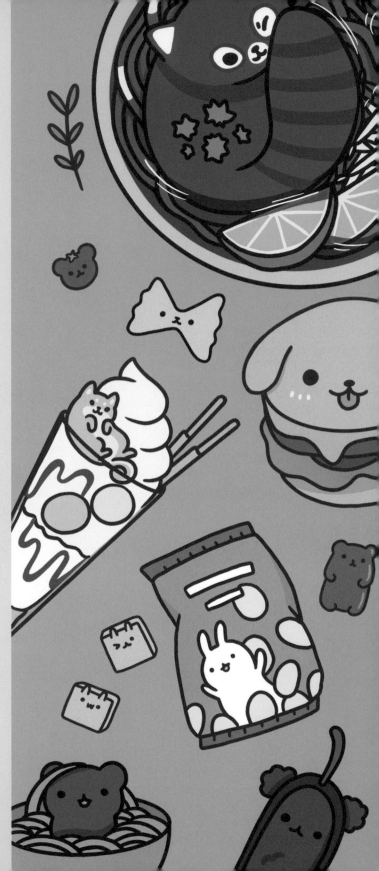

CONTENTS

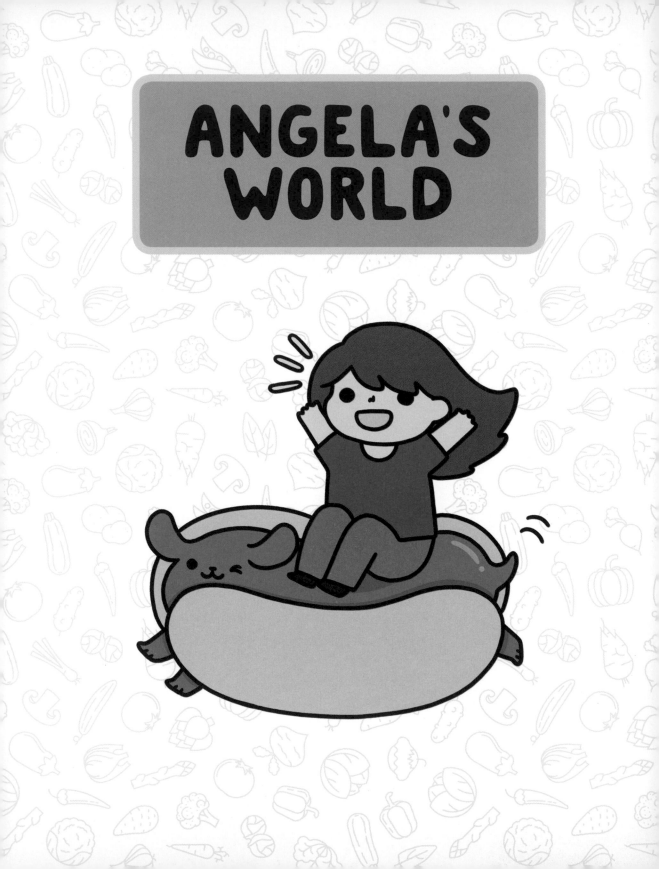

Hi there, my name is Angela!
I'm an artist who specializes in drawing cute things, especially animals and food. Anything small, round, or fluffy is my basic formula for drawing cute stuff.

For as long as I can remember, I've had the urge to draw cute things. There's just something about cuteness that never ceases to brighten a person's day.

I want to walk you through how to draw cute animals and food so that you too can brighten other people's days. Animals and food (especially) are all around us, so there will be plenty of inspiration throughout your life for reference. Follow along with my drawing journey to create cute animal-food fusions of your own.

Angela Nguyen

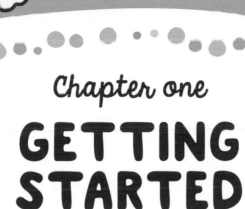

Chapter one
GETTING STARTED

You don't need special tools or materials to draw cute food. Experiment with pens, pencils, and surfaces and learn how to give your drawings cute appeal!

TOOLS AND SURFACES

There are many types of tools you can use to draw and color cute animal-food fusions. These are some of the tools that I love to use.

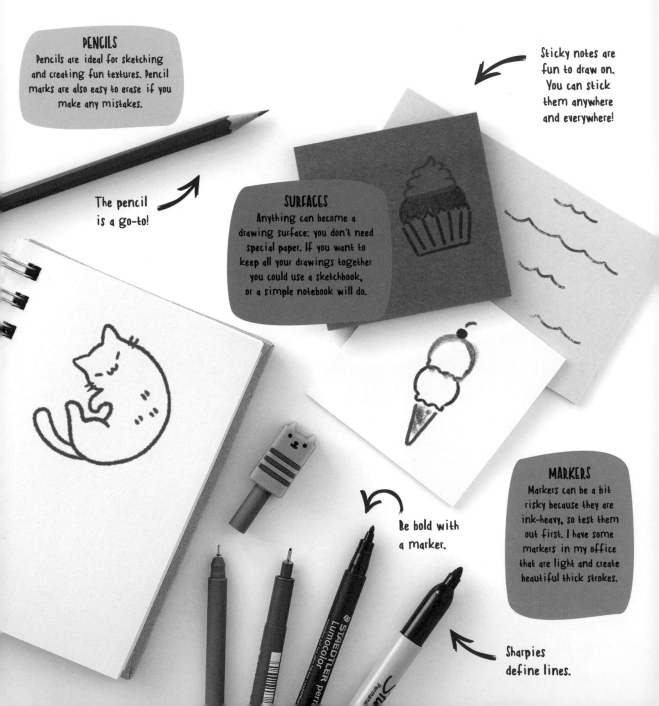

PENCILS
Pencils are ideal for sketching and creating fun textures. Pencil marks are also easy to erase if you make any mistakes.

Sticky notes are fun to draw on. You can stick them anywhere and everywhere!

The pencil is a go-to!

SURFACES
Anything can become a drawing surface: you don't need special paper. If you want to keep all your drawings together you could use a sketchbook, or a simple notebook will do.

Be bold with a marker.

MARKERS
Markers can be a bit risky because they are ink-heavy, so test them out first. I have some markers in my office that are light and create beautiful thick strokes.

Sharpies define lines.

CRAYONS

If you're going to be doing a lot of coloring, crayons can be a fun tool to play with. They make interesting textures and thick strokes.

Try not to drop colored pencils, because the lead inside will break.

Check out what crayons can do!

PENS

These are my favorite! Pens are great when you want a thin stroke. You can get precise markings, perfect for tiny whiskers or a delicate garnish.

Use art markers for rich color and vibrancy.

Metallics add sparkle!

There's no going back with a pen.

Don't forget to put a cap on your pens and markers after drawing with them, so they don't dry out.

BASICS OF FOOD ANIMALS

There are lots of ways to draw food animals.
Here are some ideas to get you started.

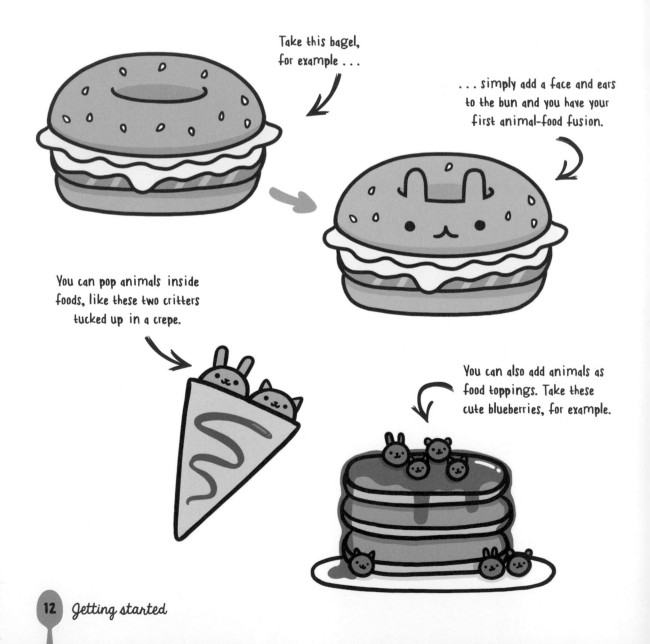

Take this bagel,
for example . . .

. . . simply add a face and ears
to the bun and you have your
first animal-food fusion.

You can pop animals inside
foods, like these two critters
tucked up in a crepe.

You can also add animals as
food toppings. Take these
cute blueberries, for example.

Simply changing the shape of the ears can be key to mixing up your food-animal creations. Cats have triangle ears. Dog ears are more floppy. Bunny ears are longer and bears have little round ears.

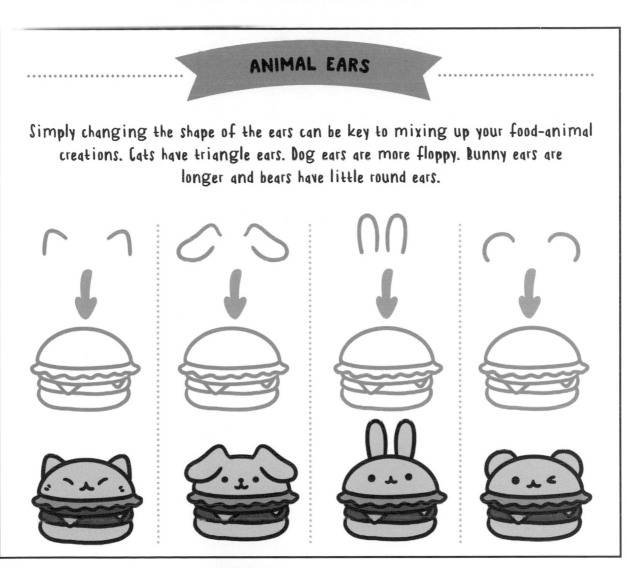

As you become more accomplished with the basic principles, try something more advanced, such as drawing a whole animal, using the food as its body.

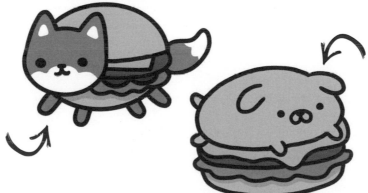

Another trick is to turn only half of the food into an animal. Here I've made just the bun into a dog.

BASICS OF CUTENESS

You can adapt these simple steps
when drawing any food animal.

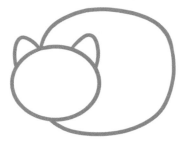

STEP 1: THE BASE

Most animals will be made of a few simple
shapes. Start by making the base with only
shapes, like two circles for the face and body.
Adding the ears helps to define the animal.

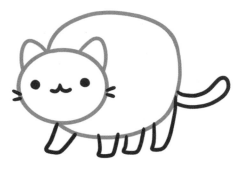

STEP 2: LIMBS

Limbs are fun! They stick out of the body in
whichever direction you choose. Depending on
the animal, you can make them long or short.
The facial features are real easy, just a few
dots and lines and your animal comes to life.

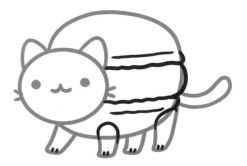

STEP 3: DETAILS

Add the details to your animal and the food.
This includes extra lines, textures, or other
features you want to show off.

STEP 4: COLORING

Finally, finish off your drawing with pastel
colors. Light colors will make your food
animal look super cute.

RULE 1: SIMPLIFY

By focusing less on the details, you can concentrate on the cuteness! Use fewer lines and simple, round strokes.

RULE 2: LIGHT COLORS

Use pastel colors to lighten your drawings. Intense, dark, or dull colors will make your drawing look too serious (unless that's what you're going for!).

RULE 3: ROUNDNESS

Round shapes like circles and curves ease the eye. They make your drawing look friendly. Look how chubby and cuddly these cute gummy bears are.

BRING YOUR DRAWINGS TO LIFE

You can bring your food animal to life with a few extra pen strokes.

Action lines are special effects you can add alongside your food animals to animate them.

Draw straight lines coming out from your animal. Surprise!

Small curved lines create simple movement effects.

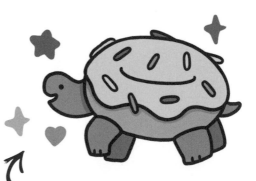

Add all sorts of fun special effects like hearts, stars, and sparkles.

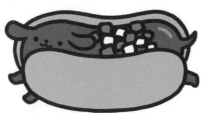

Curved lines can show that your animal is happily bouncing along.

Change the shape of the eyes, eyebrows, and mouth to show how your animal is feeling. Here are some ideas for you.

SMILEY
Neutral face

HAPPY
Open mouth

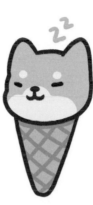

RELAXED
Closed eyes

SAD
Teardrop and downturned mouth

ANGRY
Cross mouth and steam puff

SURPRISED
Round mouth and exclamation mark

SCARED
Worried eyebrows and frowny mouth

SILLY
Tongue out

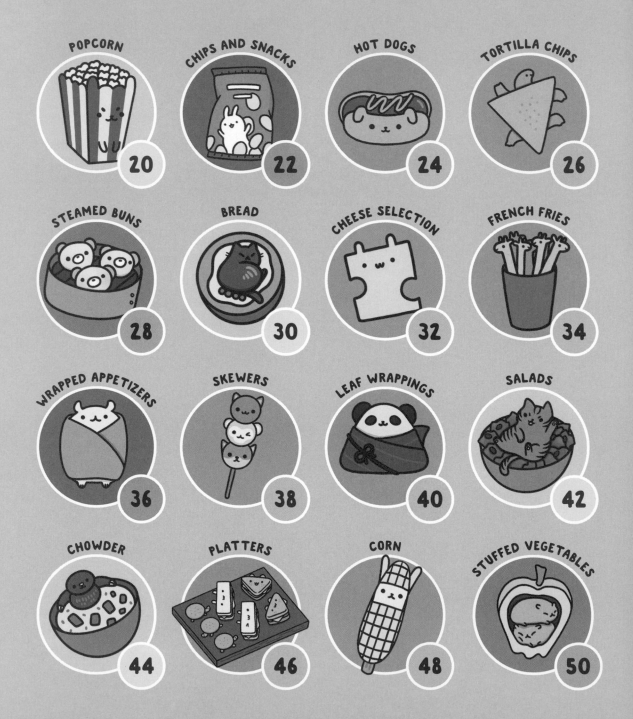

POPCORN **20**

CHIPS AND SNACKS **22**

HOT DOGS **24**

TORTILLA CHIPS **26**

STEAMED BUNS **28**

BREAD **30**

CHEESE SELECTION **32**

FRENCH FRIES **34**

WRAPPED APPETIZERS **36**

SKEWERS **38**

LEAF WRAPPINGS **40**

SALADS **42**

CHOWDER **44**

PLATTERS **46**

CORN **48**

STUFFED VEGETABLES **50**

Chapter two

SNACKS AND APPETIZERS

In this chapter you might find cute animals swimming around in your soup or wrapped up in a cozy tortilla.

POPCORN

Movie popcorn

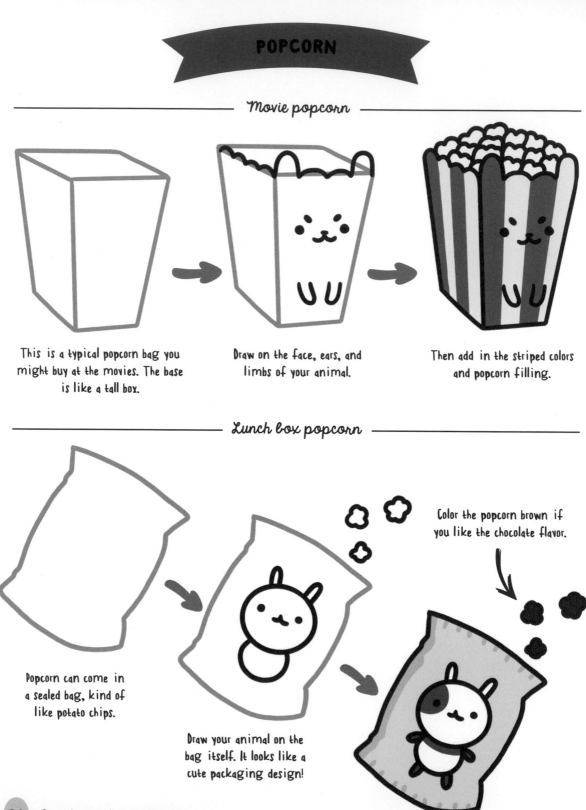

This is a typical popcorn bag you might buy at the movies. The base is like a tall box.

Draw on the face, ears, and limbs of your animal.

Then add in the striped colors and popcorn filling.

Lunch box popcorn

Popcorn can come in a sealed bag, kind of like potato chips.

Draw your animal on the bag itself. It looks like a cute packaging design!

Color the popcorn brown if you like the chocolate flavor.

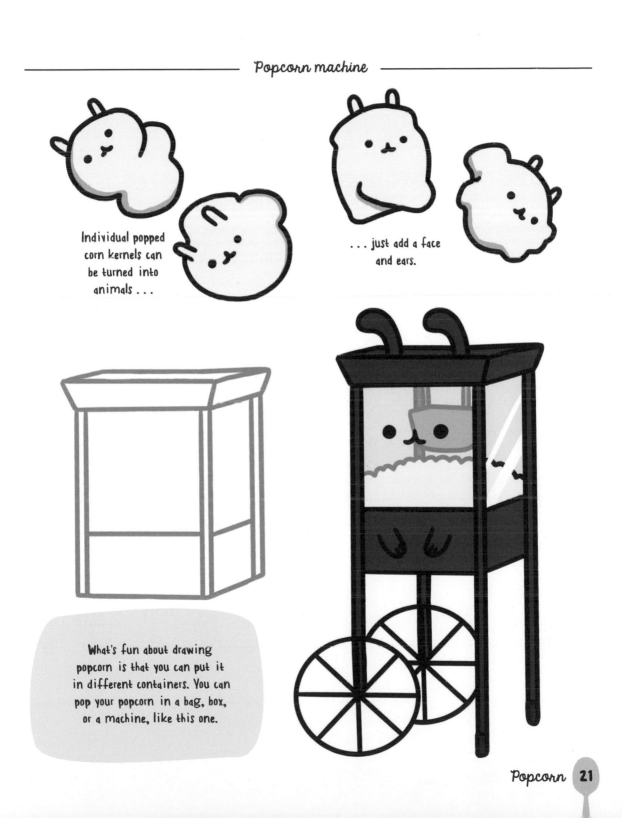

Individual popped corn kernels can be turned into animals . . .

. . . just add a face and ears.

What's fun about drawing popcorn is that you can put it in different containers. You can pop your popcorn in a bag, box, or a machine, like this one.

CHIPS AND SNACKS

Potato chips

The base of a simple potato chip is a curved oval.

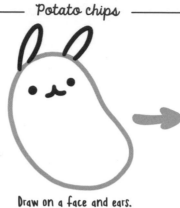

Draw on a face and ears.

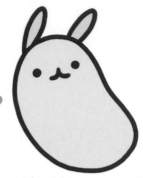

Perfecto! A bunny potato chip.

Experiment with complicated shapes to make bent and folded potato chips.

Puffed chips

Some chips look more puffy than others!

Use the entire chip as a face or a body.

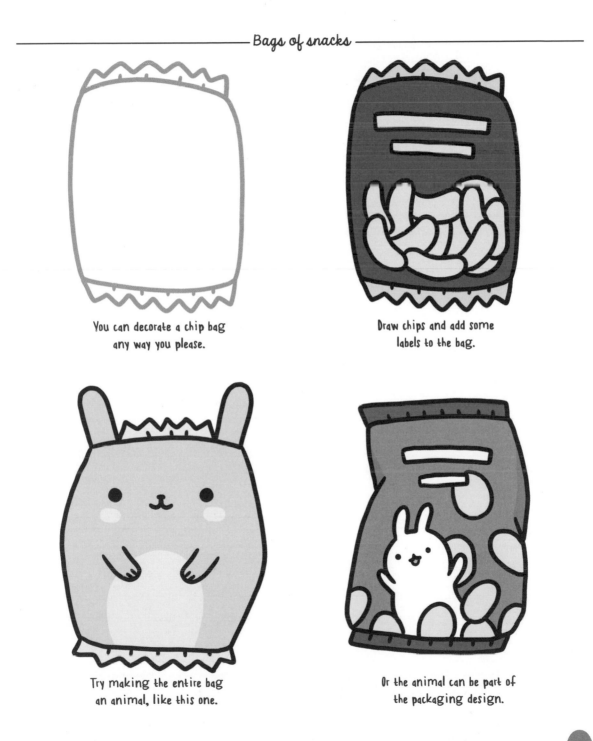

You can decorate a chip bag
any way you please.

Draw chips and add some
labels to the bag.

Try making the entire bag
an animal, like this one.

Or the animal can be part of
the packaging design.

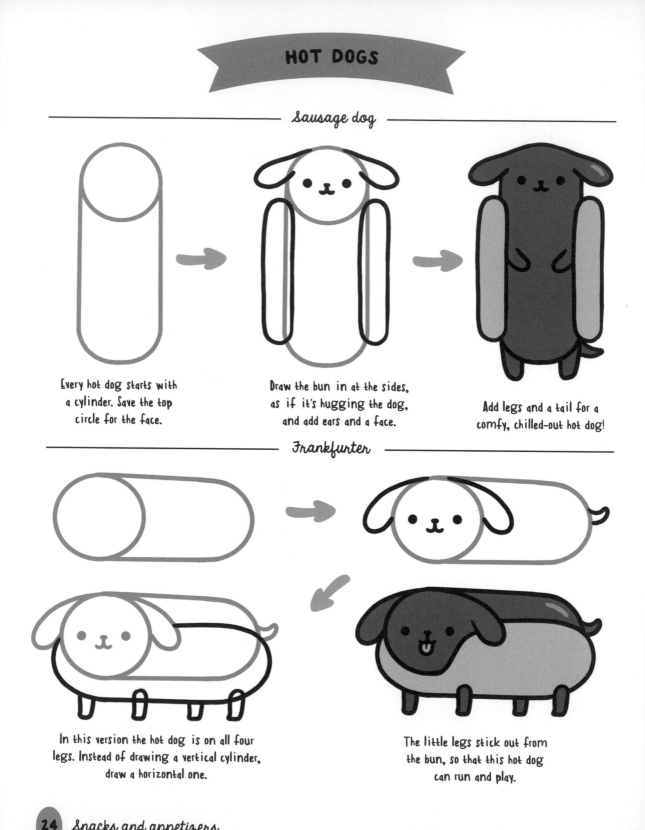

HOT DOGS

Sausage dog

Every hot dog starts with a cylinder. Save the top circle for the face.

Draw the bun in at the sides, as if it's hugging the dog, and add ears and a face.

Add legs and a tail for a comfy, chilled-out hot dog!

Frankfurter

In this version the hot dog is on all four legs. Instead of drawing a vertical cylinder, draw a horizontal one.

The little legs stick out from the bun, so that this hot dog can run and play.

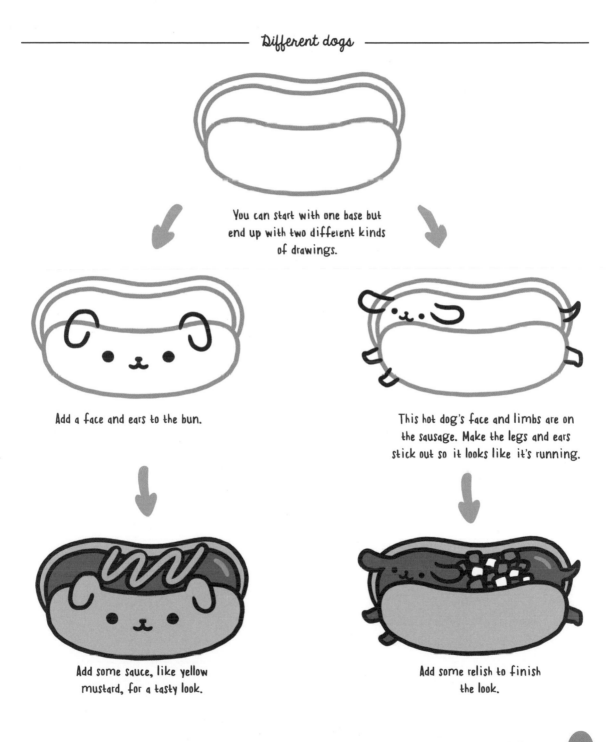

You can start with one base but end up with two different kinds of drawings.

Add a face and ears to the bun.

This hot dog's face and limbs are on the sausage. Make the legs and ears stick out so it looks like it's running.

Add some sauce, like yellow mustard, for a tasty look.

Add some relish to finish the look.

TORTILLA CHIPS

Tortilla shell

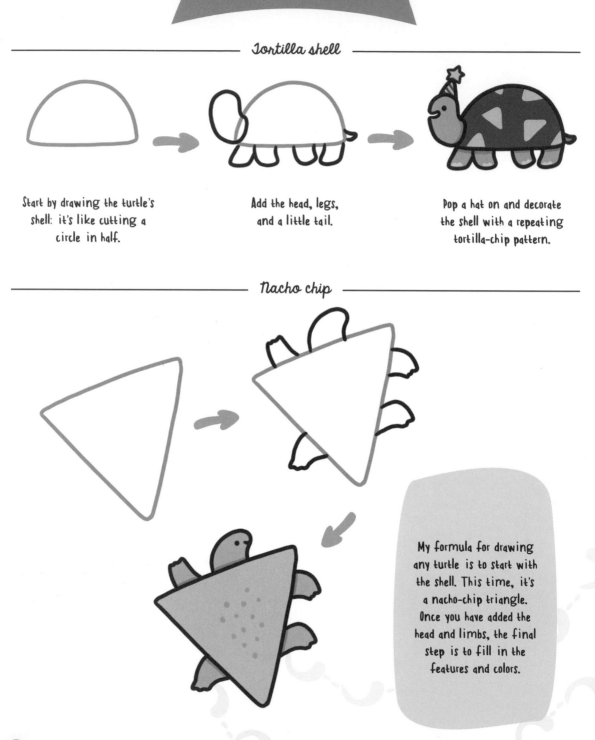

Start by drawing the turtle's shell: it's like cutting a circle in half.

Add the head, legs, and a little tail.

Pop a hat on and decorate the shell with a repeating tortilla-chip pattern.

Nacho chip

My formula for drawing any turtle is to start with the shell. This time, it's a nacho-chip triangle. Once you have added the head and limbs, the final step is to fill in the features and colors.

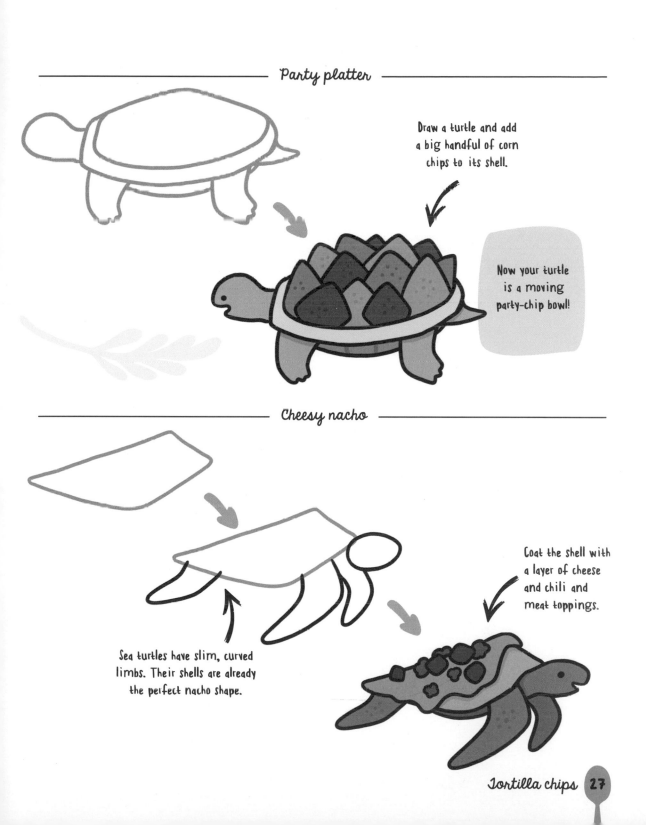

Party platter

Draw a turtle and add a big handful of corn chips to its shell.

Now your turtle is a moving party-chip bowl!

Cheesy nacho

Sea turtles have slim, curved limbs. Their shells are already the perfect nacho shape.

Coat the shell with a layer of cheese and chili and meat toppings.

Tortilla chips 27

Animal buns

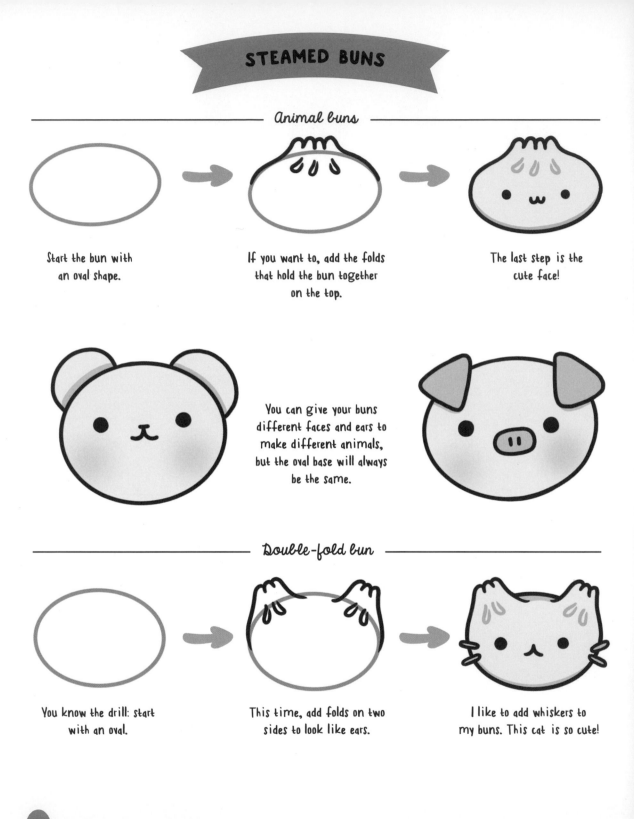

Start the bun with
an oval shape.

If you want to, add the folds
that hold the bun together
on the top.

The last step is the
cute face!

You can give your buns
different faces and ears to
make different animals,
but the oval base will always
be the same.

Double-fold bun

You know the drill: start
with an oval.

This time, add folds on two
sides to look like ears.

I like to add whiskers to
my buns. This cat is so cute!

Give your buns little bamboo homes. Draw the basic shape of a bamboo steamer.

Now add the oval shapes for the buns.

Add in the details and finishing touches.

Check out how I added crease lines to the bun where the chopsticks pinch it. Ouch! It really looks like the soft bun is being pulled.

BREAD

Bruschetta

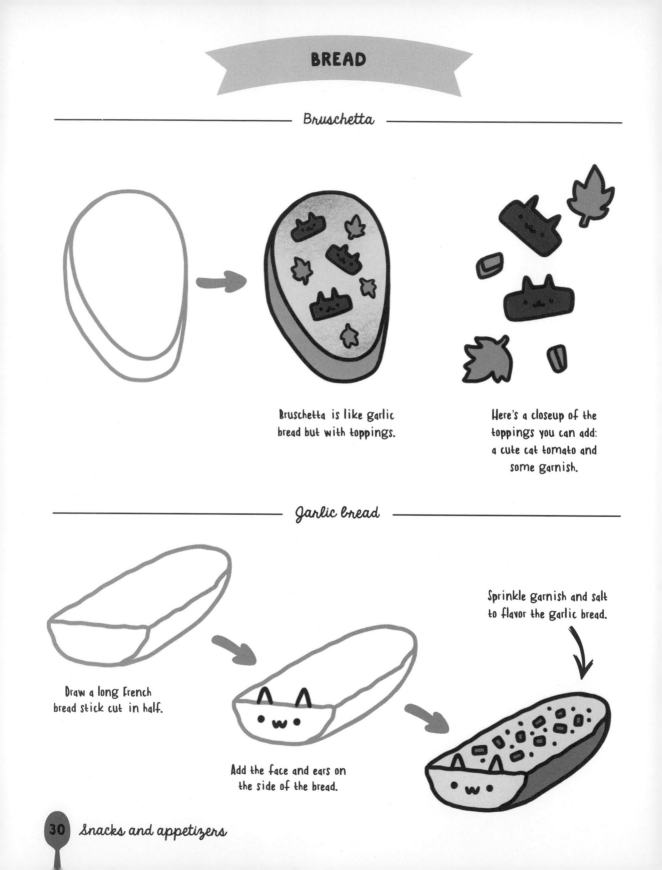

Bruschetta is like garlic bread but with toppings.

Here's a closeup of the toppings you can add: a cute cat tomato and some garnish.

Garlic bread

Draw a long French bread stick cut in half.

Add the face and ears on the side of the bread.

Sprinkle garnish and salt to flavor the garlic bread.

Cubed toppings

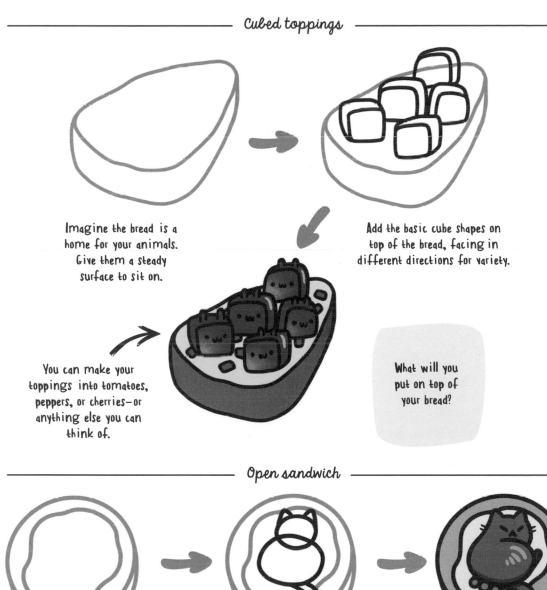

Imagine the bread is a home for your animals. Give them a steady surface to sit on.

Add the basic cube shapes on top of the bread, facing in different directions for variety.

You can make your toppings into tomatoes, peppers, or cherries—or anything else you can think of.

What will you put on top of your bread?

Open sandwich

Draw a round base of bread roll and draw a smear of cheese on top.

Add the basic shapes for a napping animal.

The colorful red cat and its green pea cushion stand out against the neutral cheese and bread.

CHEESE SELECTION

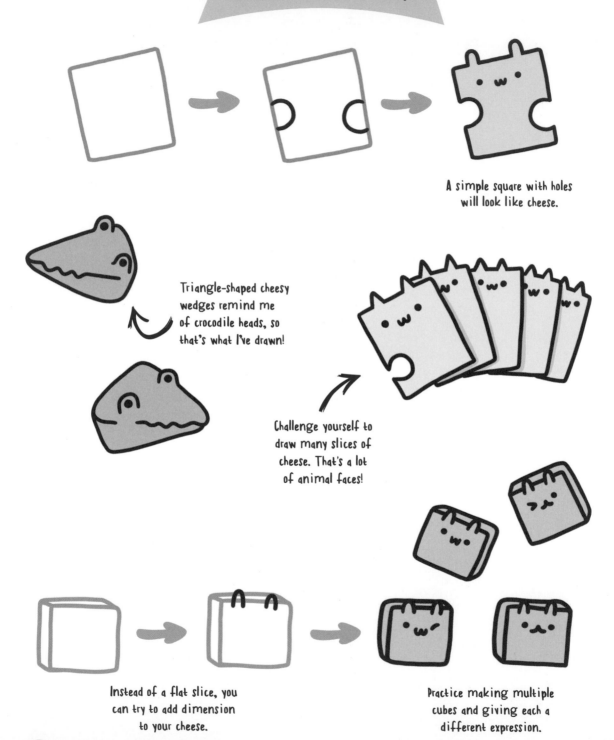

A simple square with holes will look like cheese.

Triangle-shaped cheesy wedges remind me of crocodile heads, so that's what I've drawn!

Challenge yourself to draw many slices of cheese. That's a lot of animal faces!

Instead of a flat slice, you can try to add dimension to your cheese.

Practice making multiple cubes and giving each a different expression.

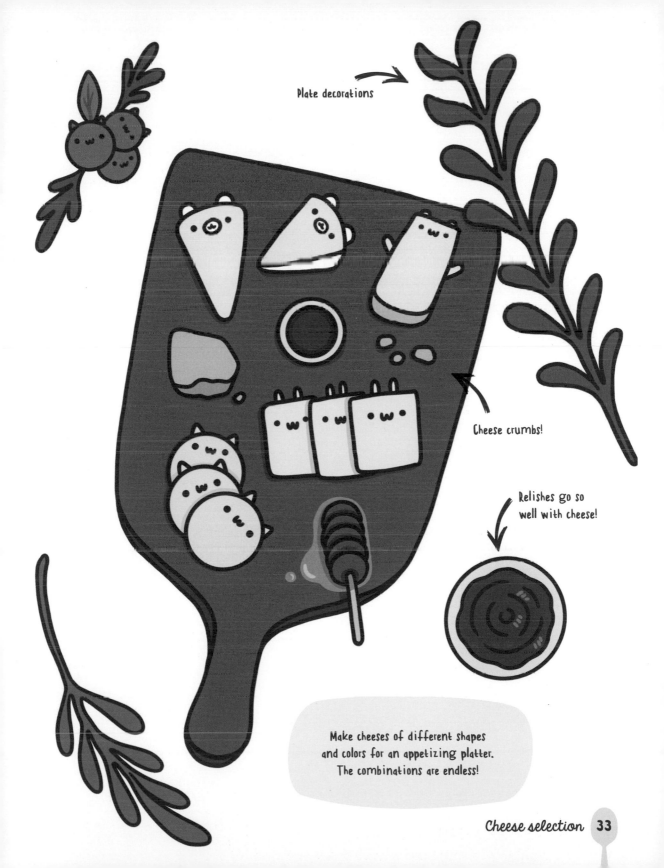

Plate decorations

Cheese crumbs!

Relishes go so well with cheese!

Make cheeses of different shapes
and colors for an appetizing platter.
The combinations are endless!

FRENCH FRIES

Fries

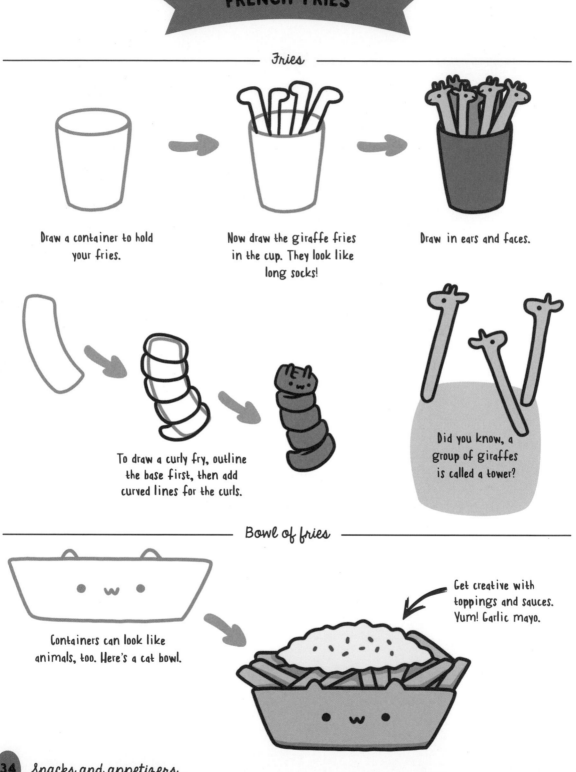

Draw a container to hold your fries.

Now draw the giraffe fries in the cup. They look like long socks!

Draw in ears and faces.

To draw a curly fry, outline the base first, then add curved lines for the curls.

Did you know, a group of giraffes is called a tower?

Bowl of fries

Containers can look like animals, too. Here's a cat bowl.

Get creative with toppings and sauces. Yum! Garlic mayo.

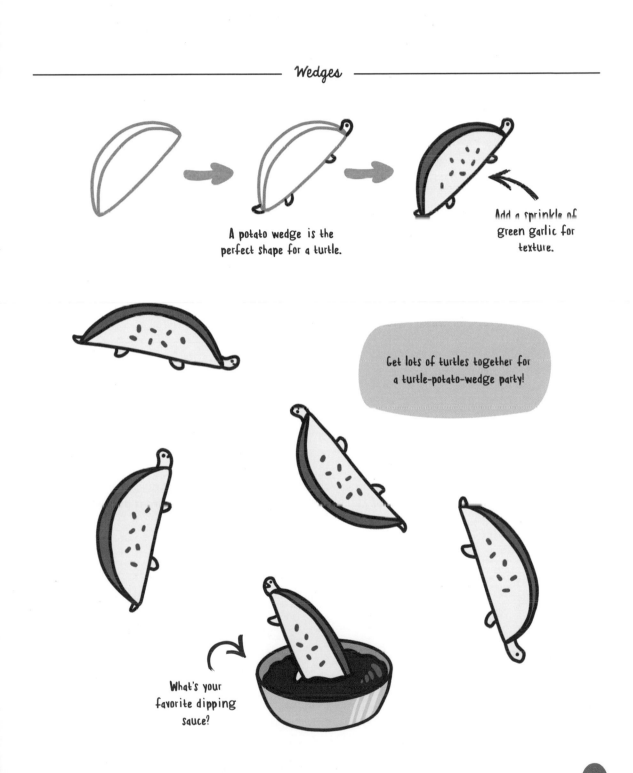

A potato wedge is the perfect shape for a turtle.

Add a sprinkle of green garlic for texture.

Get lots of turtles together for a turtle-potato-wedge party!

What's your favorite dipping sauce?

WRAPPED APPETIZERS

Piggy in a blanket

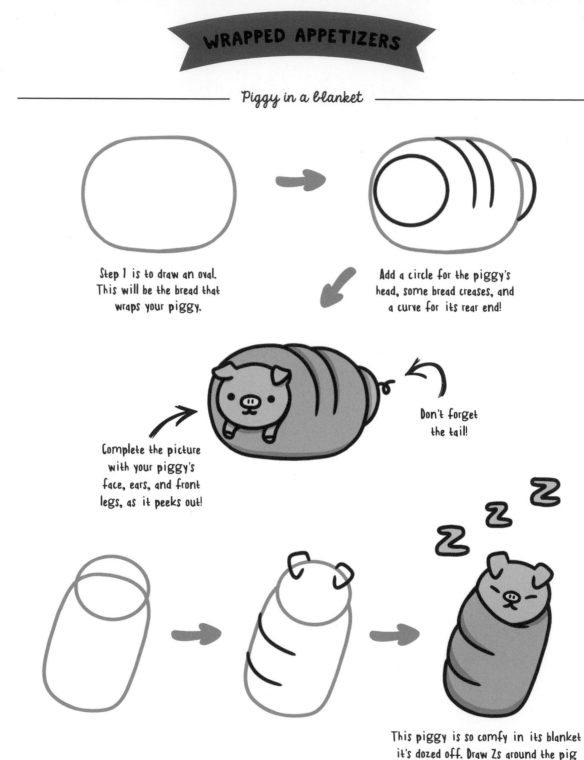

Step 1 is to draw an oval. This will be the bread that wraps your piggy.

Add a circle for the piggy's head, some bread creases, and a curve for its rear end!

Complete the picture with your piggy's face, ears, and front legs, as it peeks out!

Don't forget the tail!

This piggy is so comfy in its blanket it's dozed off. Draw Zs around the pig to show that it's fast asleep.

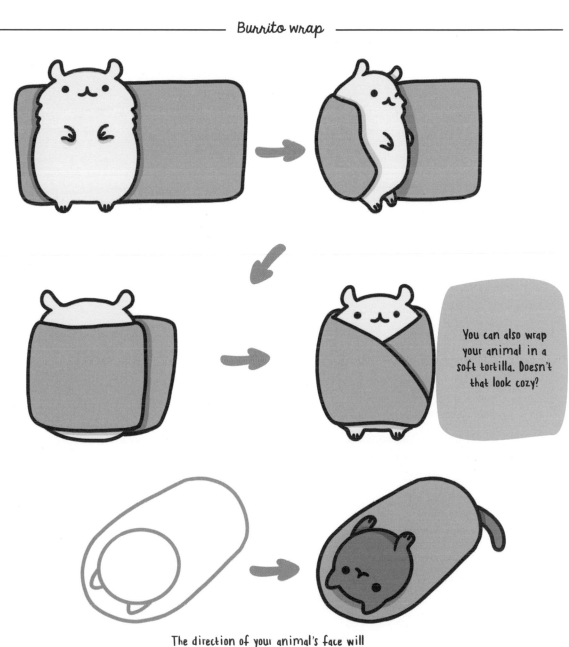

You can also wrap your animal in a soft tortilla. Doesn't that look cozy?

The direction of your animal's face will show how it is wrapped. This pink cat is lying upside down.

Stacked kabob

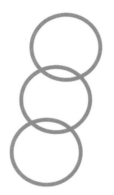

Draw three circles stacked on top of one another.

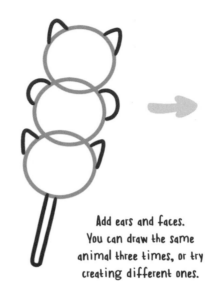

Add ears and faces. You can draw the same animal three times, or try creating different ones.

Here's a coloring tip for skewers: color all the animals the same or a similar hue, but separate them on the skewer with colorful dividers.

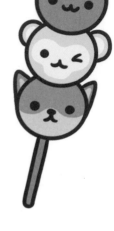

These colorful squiggly shapes look like slices of pepper.

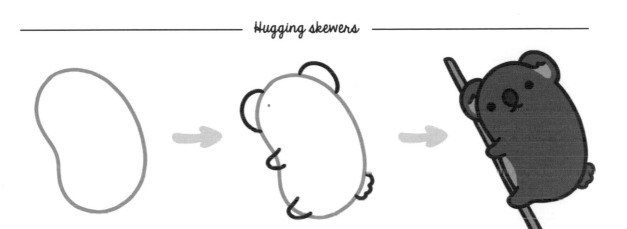

Draw a jelly-bean shape for the body of your hugging animal.

Add the ears, limbs, and a fluffy tail.

Continue to build the features of your animal, and add in the skewer for it to hug onto.

This pose is perfect for animals that like to climb or hang onto things. You could try koalas, sloths, monkeys, or squirrels.

Did you know that adult pandas don't spend much time climbing, but baby pandas love it.

Leaf roll

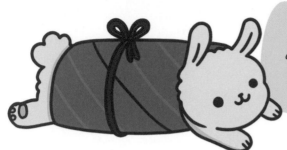

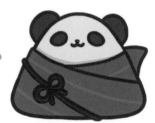

Food can be leaf-wrapped to protect the ingredients and also add yummy flavors! This bunny has been rolled up in a leaf blanket.

Triangle wrap

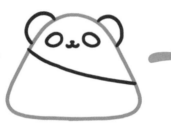

Start with a rounded triangle base.

Add a face and ears, and a diagonal line to mark the main part of the leaf.

Complete the rest of the leaf wrapping, plus a bow to keep it all together.

Cigar wrap

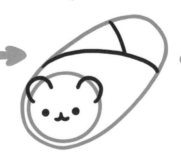

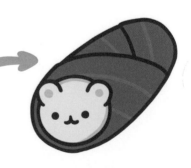

This time, draw a cylinder.

Draw the bear's face and ears in the circle opening and add leaf fold lines.

Use a light color for the bear so it stands out against the dark green leaf.

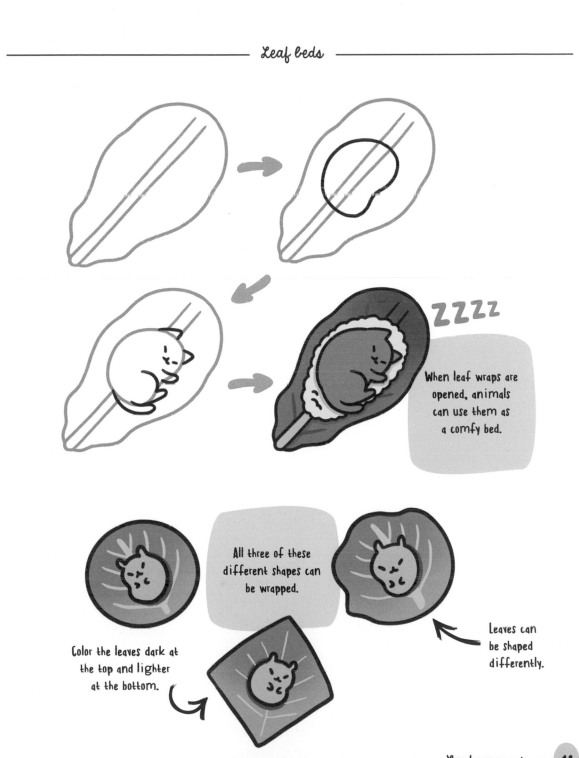

ZZZZ

When leaf wraps are opened, animals can use them as a comfy bed.

All three of these different shapes can be wrapped.

Color the leaves dark at the top and lighter at the bottom.

Leaves can be shaped differently.

SALADS

Leaf salad

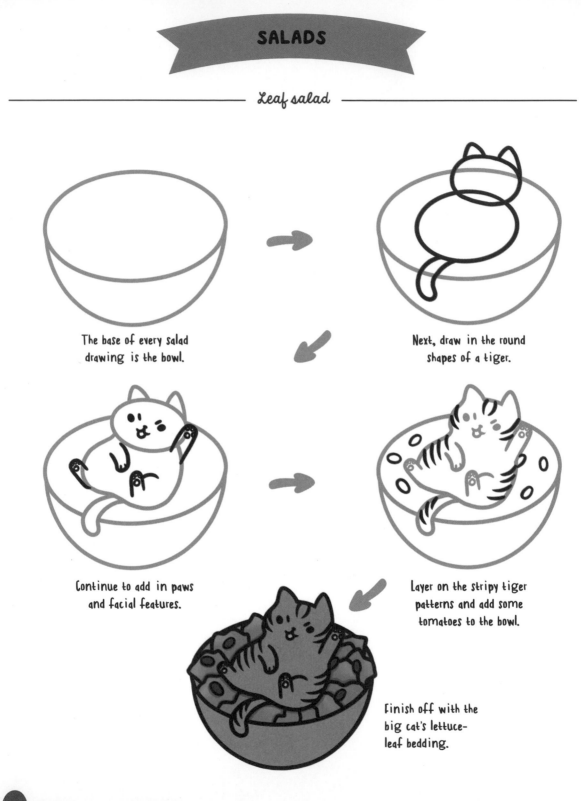

The base of every salad drawing is the bowl.

Next, draw in the round shapes of a tiger.

Continue to add in paws and facial features.

Layer on the stripy tiger patterns and add some tomatoes to the bowl.

Finish off with the big cat's lettuce-leaf bedding.

Mixed salad

You know the drill: draw your bowl!

Fill the bowl with leaf textures.

Add ingredients to make an animal face, such as green olive eyes and sliced tomato ears.

Cheese salad

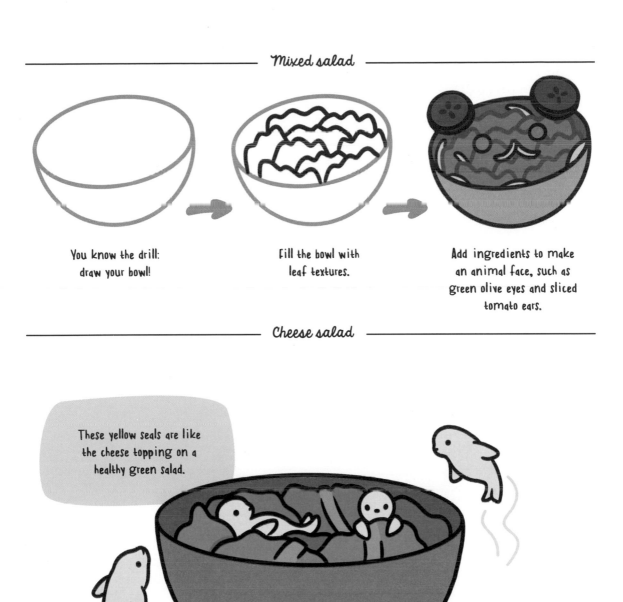

These yellow seals are like the cheese topping on a healthy green salad.

CHOWDER

Cup of soup

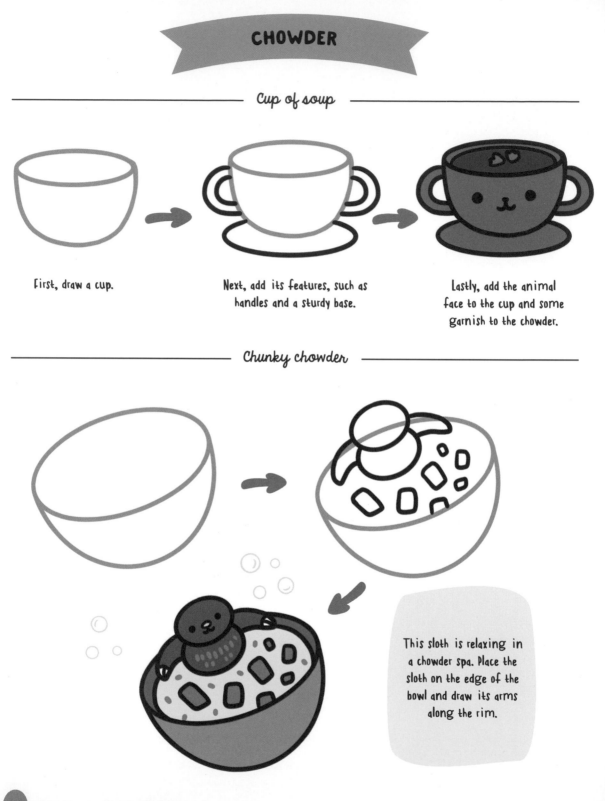

First, draw a cup.

Next, add its features, such as handles and a sturdy base.

Lastly, add the animal face to the cup and some garnish to the chowder.

Chunky chowder

This sloth is relaxing in a chowder spa. Place the sloth on the edge of the bowl and draw its arms along the rim.

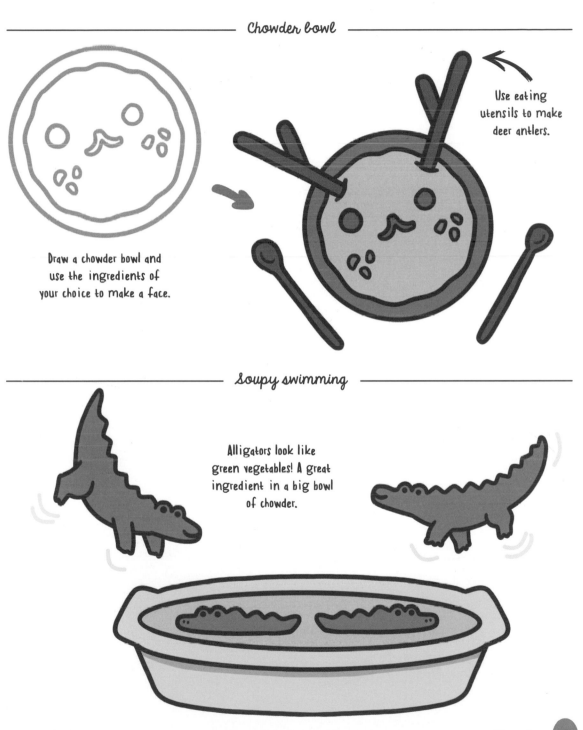

Chowder bowl

Draw a chowder bowl and use the ingredients of your choice to make a face.

Use eating utensils to make deer antlers.

Soupy swimming

Alligators look like green vegetables! A great ingredient in a big bowl of chowder.

PLATTERS

Sandwich platter

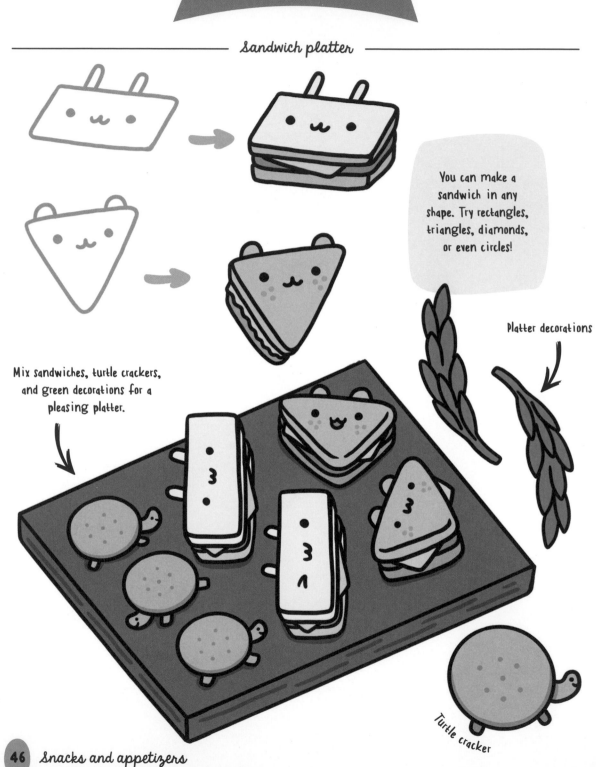

You can make a sandwich in any shape. Try rectangles, triangles, diamonds, or even circles!

Platter decorations

Mix sandwiches, turtle crackers, and green decorations for a pleasing platter.

Turtle cracker

Fruit platter

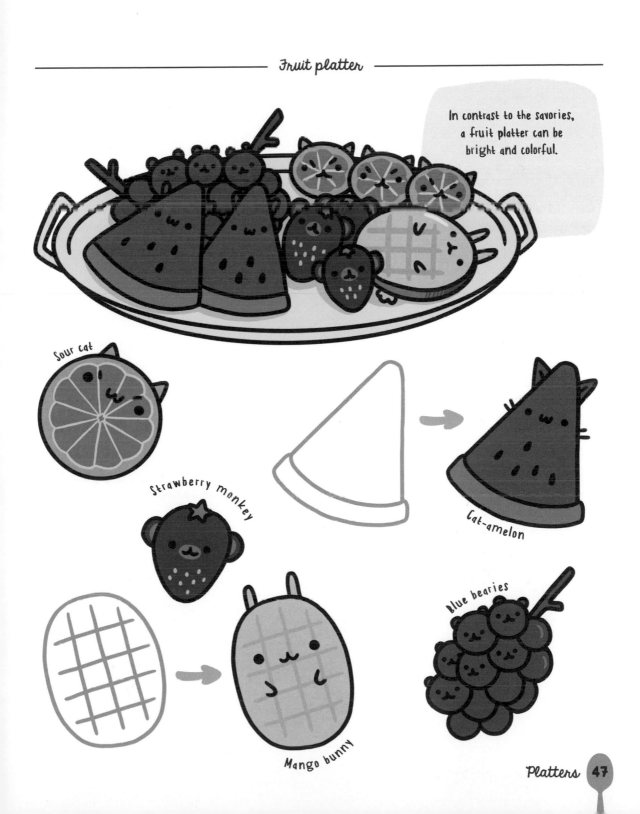

In contrast to the savories, a fruit platter can be bright and colorful.

Sour cat

Strawberry monkey

Cat-amelon

Mango bunny

Blue bearies

CORN

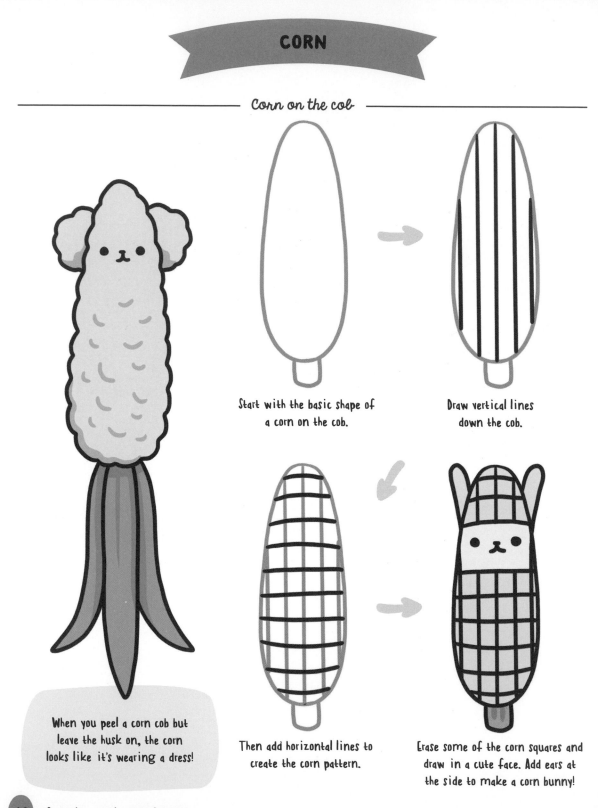

Corn on the cob

Start with the basic shape of a corn on the cob.

Draw vertical lines down the cob.

When you peel a corn cob but leave the husk on, the corn looks like it's wearing a dress!

Then add horizontal lines to create the corn pattern.

Erase some of the corn squares and draw in a cute face. Add ears at the side to make a corn bunny!

Corn bread

Corn bread is a
block of cuteness!

It is typically crumbly, so
add little crumbs around
your corn-bread animal.

Corn kernels

Corn kernels can
be drawn as loose,
individual pieces,
each one with its
own little face.

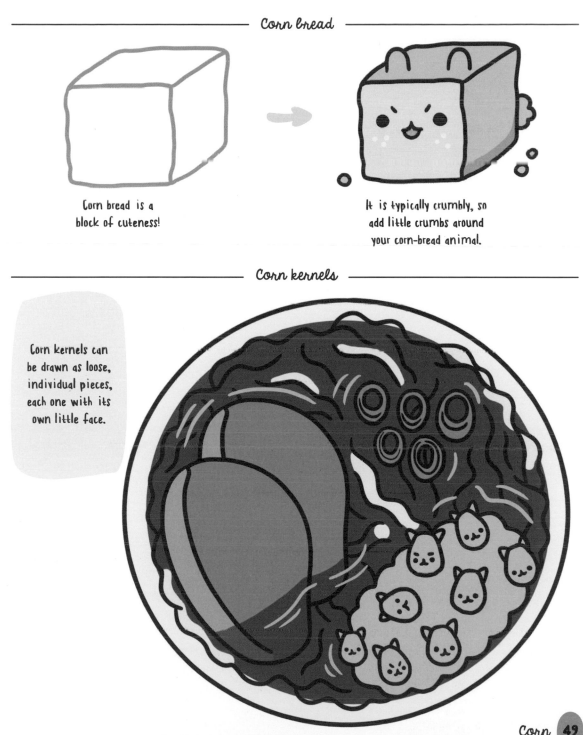

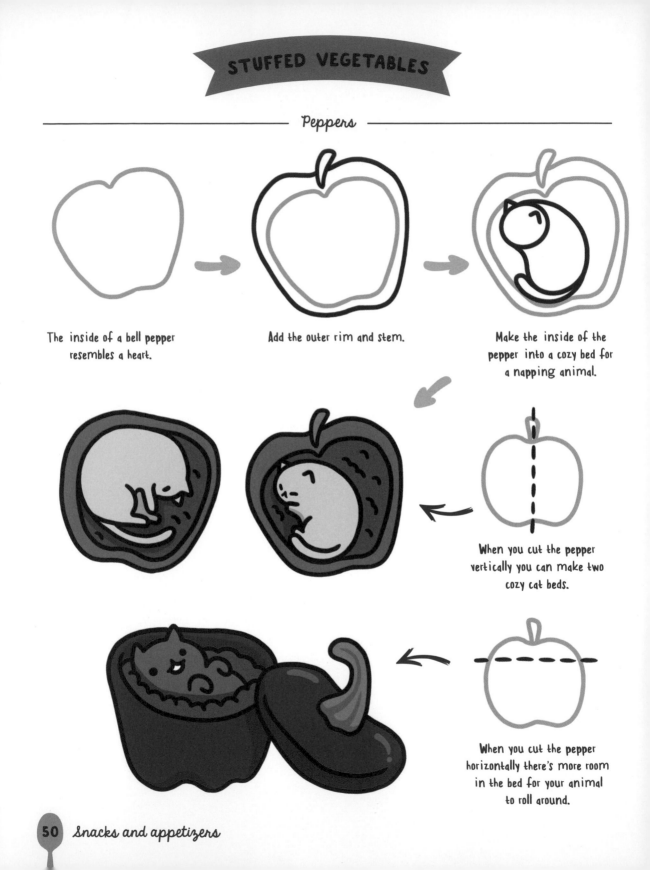

STUFFED VEGETABLES

Peppers

The inside of a bell pepper resembles a heart.

Add the outer rim and stem.

Make the inside of the pepper into a cozy bed for a napping animal.

When you cut the pepper vertically you can make two cozy cat beds.

When you cut the pepper horizontally there's more room in the bed for your animal to roll around.

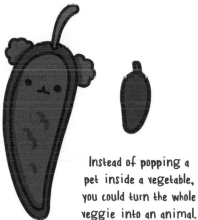

Instead of popping a pet inside a vegetable, you could turn the whole veggie into an animal.

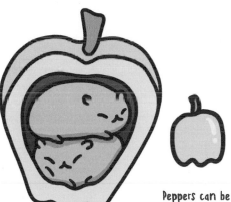

Peppers can be colored yellow to look sweeter. You can also try squishing two animals into one bed.

Experiment with different vegetables, colors, and animals. This russet fox is curled up and comfy in an orange squash.

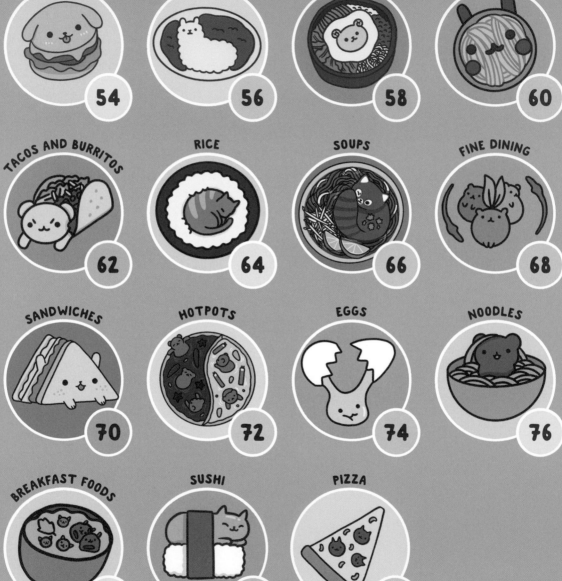

Chapter three

ENTRÉES

What could be cuter than a red panda asleep on your noodles, or a bunny bun for a burger? There are lots of other ideas to try for cute creature creations.

Cheeseburger

Start at the top of the
hamburger by drawing
a bun and some cheese.

Pop some round ears on
top of the bun, then work
your way down, adding the
burger, lettuce, and
the bottom bun.

Draw in the animal face
and color the hamburger.

The top bun can be used to
illustrate any kind of animal. The
trick is how you draw the ears. Try
ears that point up or droop down.

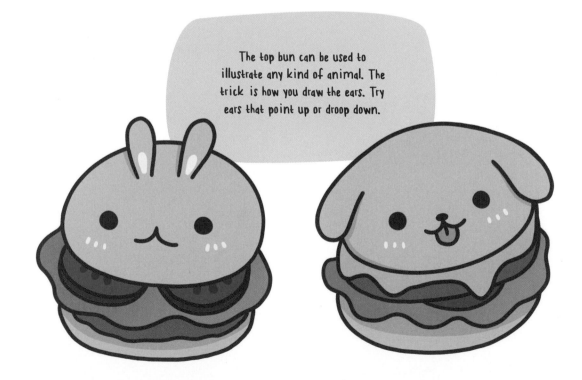

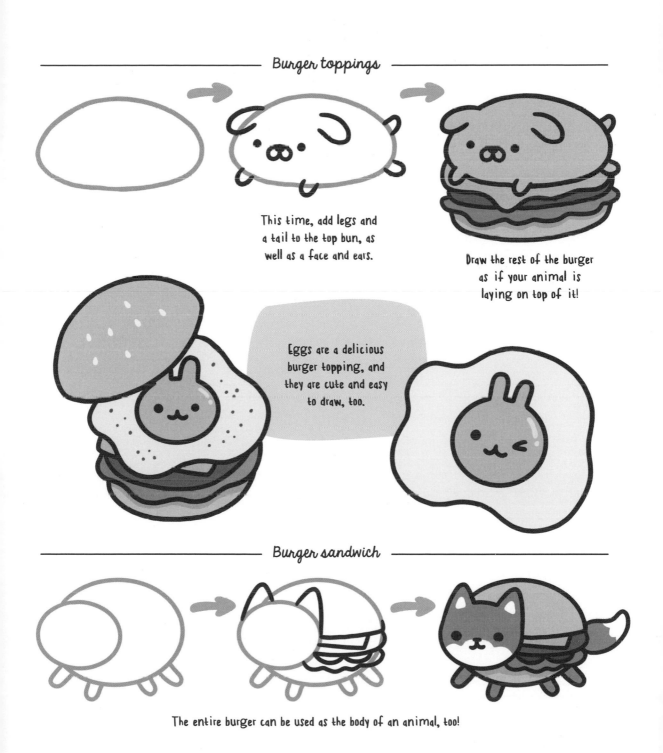

Burger toppings

This time, add legs and a tail to the top bun, as well as a face and ears.

Draw the rest of the burger as if your animal is laying on top of it!

Eggs are a delicious burger topping, and they are cute and easy to draw, too.

Burger sandwich

The entire burger can be used as the body of an animal, too!

CURRY

Curry and rice

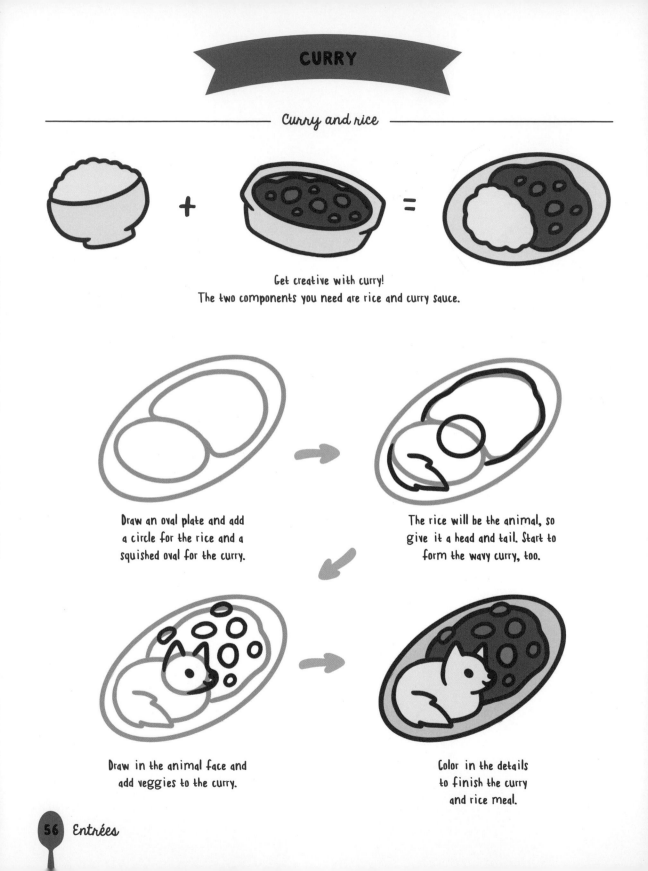

Get creative with curry!
The two components you need are rice and curry sauce.

Draw an oval plate and add
a circle for the rice and a
squished oval for the curry.

The rice will be the animal, so
give it a head and tail. Start to
form the wavy curry, too.

Draw in the animal face and
add veggies to the curry.

Color in the details
to finish the curry
and rice meal.

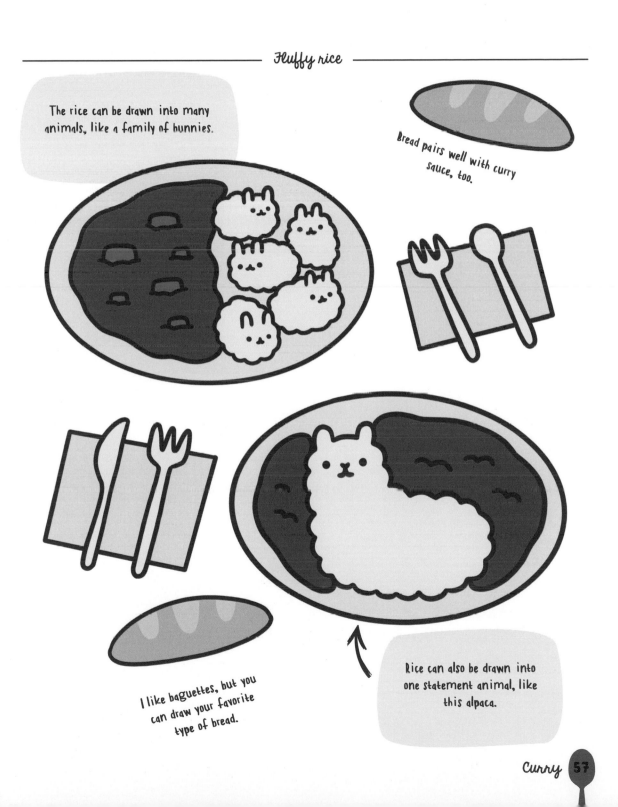

The rice can be drawn into many animals, like a family of bunnies.

Bread pairs well with curry sauce, too.

I like baguettes, but you can draw your favorite type of bread.

Rice can also be drawn into one statement animal, like this alpaca.

STONE POTS

Mixed pot

Stone pot dishes can include lots of ingredients all mixed in together.

The egg has a cute sheep's face.

Simple, bumpy textures can add interesting flavors to the dish.

Use vegetables to give your pot color.

Bean sprouts are fun to draw because they are so loose and squiggly.

Eggy rice

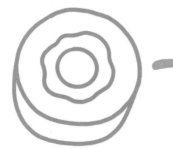

Start this drawing with the pot and an egg.

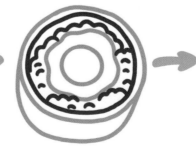

Draw rice around the egg.

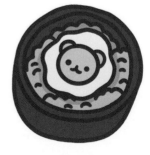

Give the yolk a bear's face and color in the drawing.

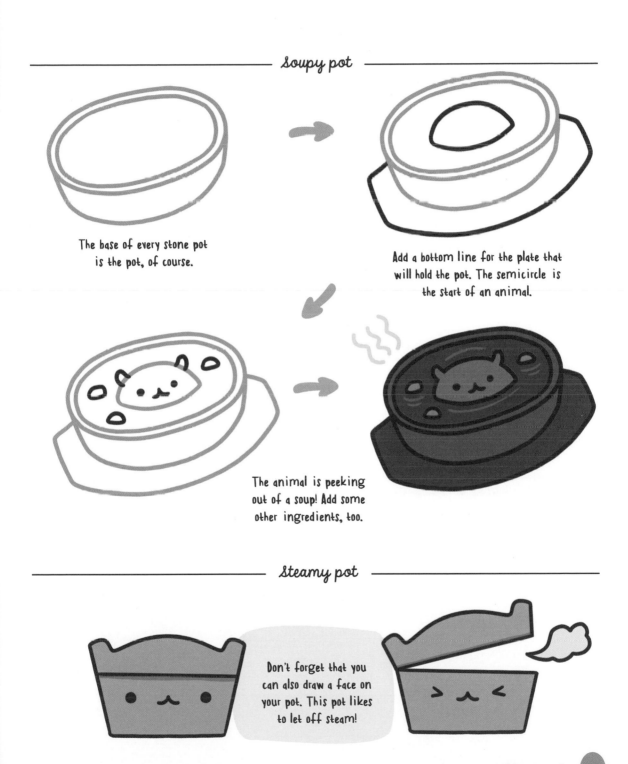

Soupy pot

The base of every stone pot is the pot, of course.

Add a bottom line for the plate that will hold the pot. The semicircle is the start of an animal.

The animal is peeking out of a soup! Add some other ingredients, too.

Steamy pot

Don't forget that you can also draw a face on your pot. This pot likes to let off steam!

Pasta shapes

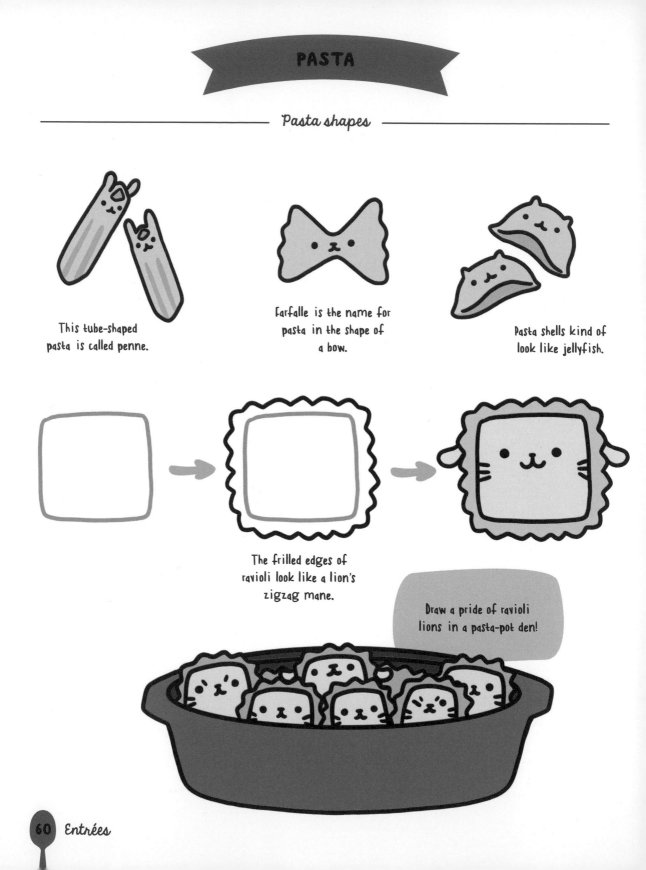

This tube-shaped pasta is called penne.

Farfalle is the name for pasta in the shape of a bow.

Pasta shells kind of look like jellyfish.

The frilled edges of ravioli look like a lion's zigzag mane.

Draw a pride of ravioli lions in a pasta-pot den!

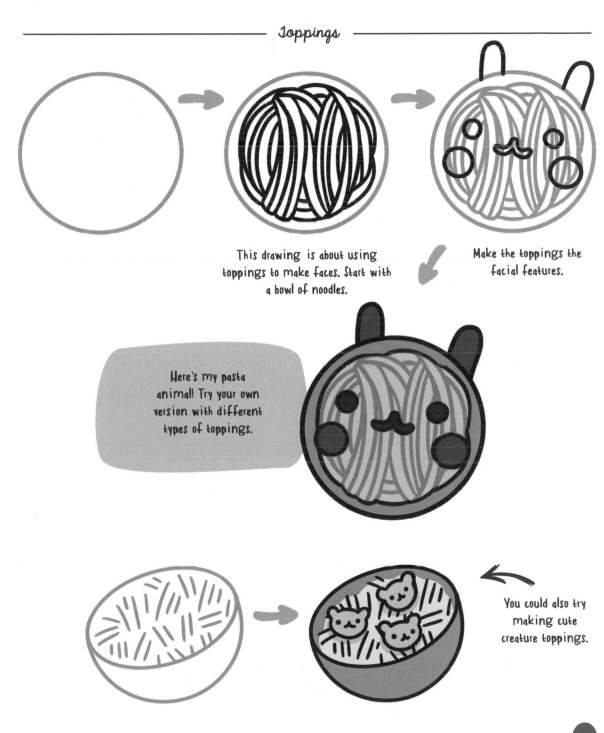

This drawing is about using toppings to make faces. Start with a bowl of noodles.

Make the toppings the facial features.

Here's my pasta animal! Try your own version with different types of toppings.

You could also try making cute creature toppings.

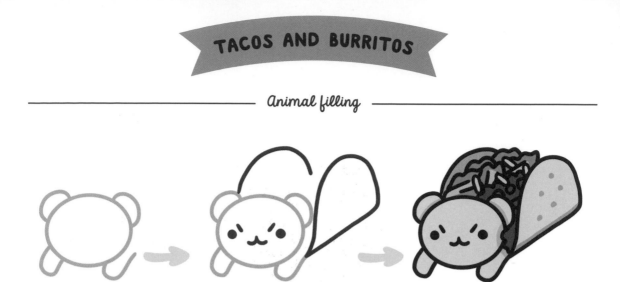

Animal filling

Start with the head and paws of your animal . . .

. . . then add the taco shell so that the animal is laying inside it. Give your animal a face, too.

Add your choice of foody toppings and fillings.

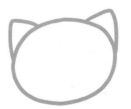

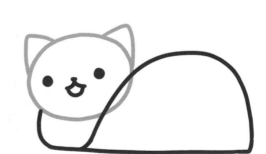

You could make the taco a part of your animal, like this cat's body. See how its legs and tail stick out from the shell.

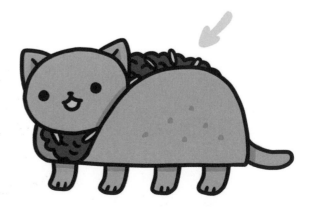

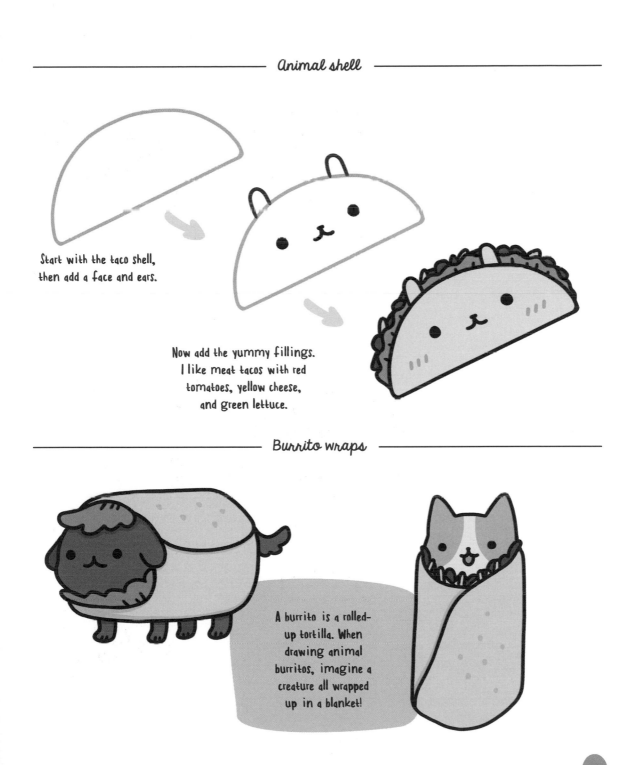

Start with the taco shell, then add a face and ears.

Now add the yummy fillings. I like meat tacos with red tomatoes, yellow cheese, and green lettuce.

Burrito wraps

A burrito is a rolled-up tortilla. When drawing animal burritos, imagine a creature all wrapped up in a blanket!

Rice balls

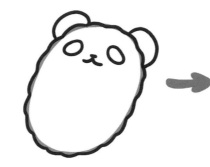

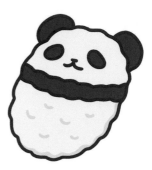

Start with an oval as the base of your rice ball.

Draw bumpy lines around the base for the rice texture, and add ears and facial features.

Draw seaweed around the rice ball to make it look even more like a panda and add color.

Try different patterns and shapes for the seaweed to create a family of pandas. They all start with the same base.

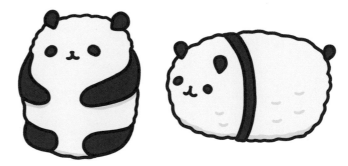

Onigiri

Onigiri is a Japanese-style rice ball shaped like a triangle and wrapped in seaweed.

Like the balls above, draw a bumpy line around the base shape. Add ears.

Add a face and color the seaweed and ears. I've made a bunny onigiri.

Rolled rice

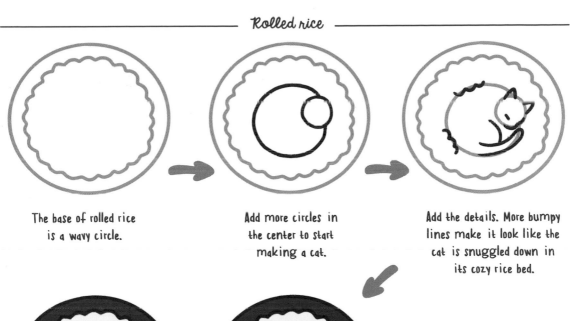

The base of rolled rice
is a wavy circle.

Add more circles in
the center to start
making a cat.

Add the details. More bumpy
lines make it look like the
cat is snuggled down in
its cozy rice bed.

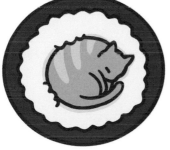

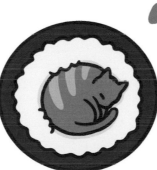

Pick a cute light color to
fill in your cat; here are
orange and pink examples.

Lunch box

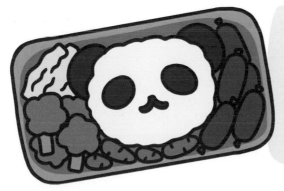

Draw an assorted
lunch box with
a rice face and
some vegetables
for color!

SOUPS

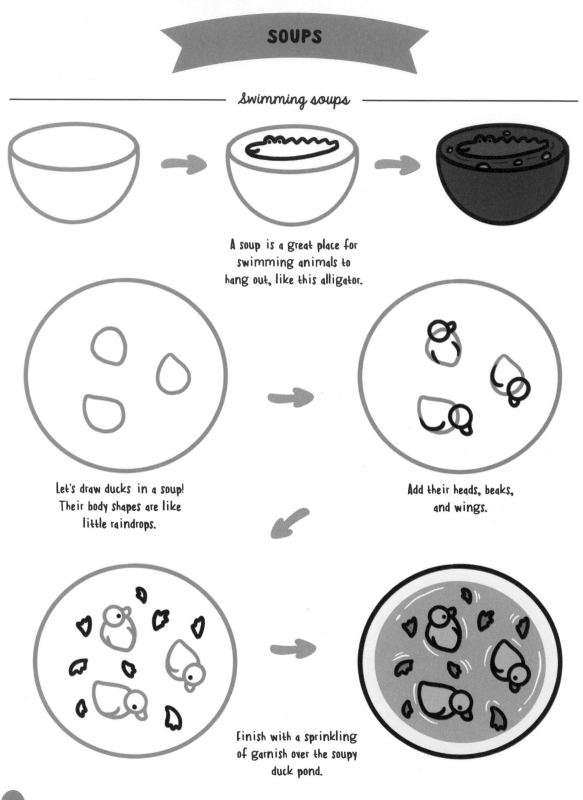

Swimming soups

A soup is a great place for swimming animals to hang out, like this alligator.

Let's draw ducks in a soup! Their body shapes are like little raindrops.

Add their heads, beaks, and wings.

Finish with a sprinkling of garnish over the soupy duck pond.

The key to making your drawing look soupy is to have some noodles popping in and out of the soup. Add a rippling effect with lines around the ingredients.

You can add other ingredients alongside your red panda. Here I added bean sprouts and lime wedges.

— *Sauces* —

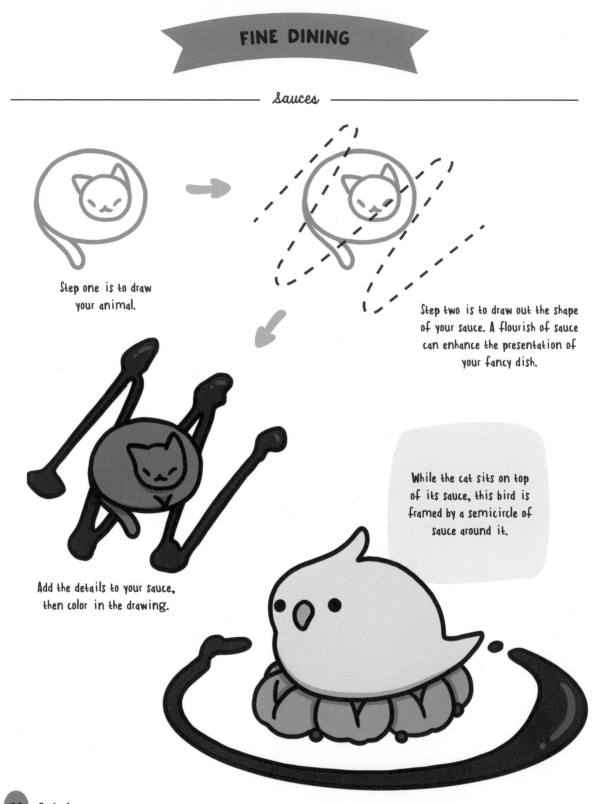

Step one is to draw your animal.

Step two is to draw out the shape of your sauce. A flourish of sauce can enhance the presentation of your fancy dish.

Add the details to your sauce, then color in the drawing.

While the cat sits on top of its sauce, this bird is framed by a semicircle of sauce around it.

Garnishes

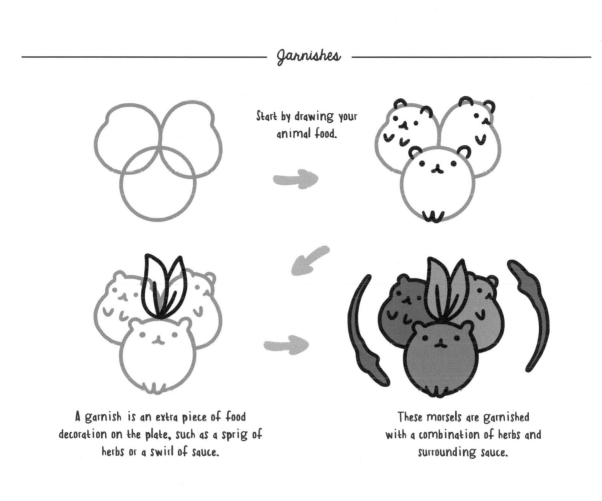

Start by drawing your animal food.

A garnish is an extra piece of food decoration on the plate, such as a sprig of herbs or a swirl of sauce.

These morsels are garnished with a combination of herbs and surrounding sauce.

Simplicity

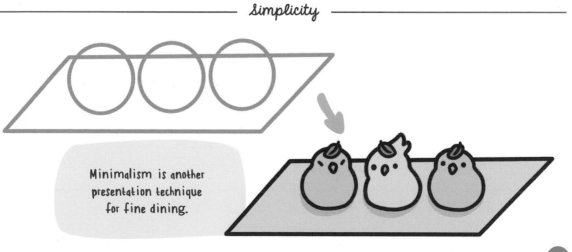

Minimalism is another presentation technique for fine dining.

SANDWICHES

Baguette

 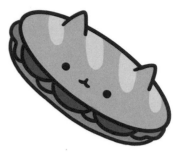

A baguette is a long piece of bread, so start by drawing an oval.

Draw the baguette fillings underneath the oval.

Add a partial oval under the fillings, then add the animal's face and ears to the top of the baguette.

Tea sandwich

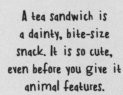

A tea sandwich is a dainty, bite-size snack. It is so cute, even before you give it animal features.

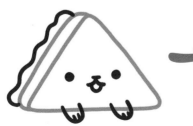

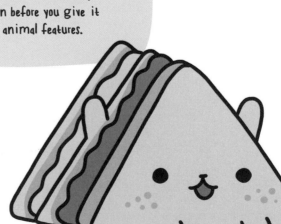

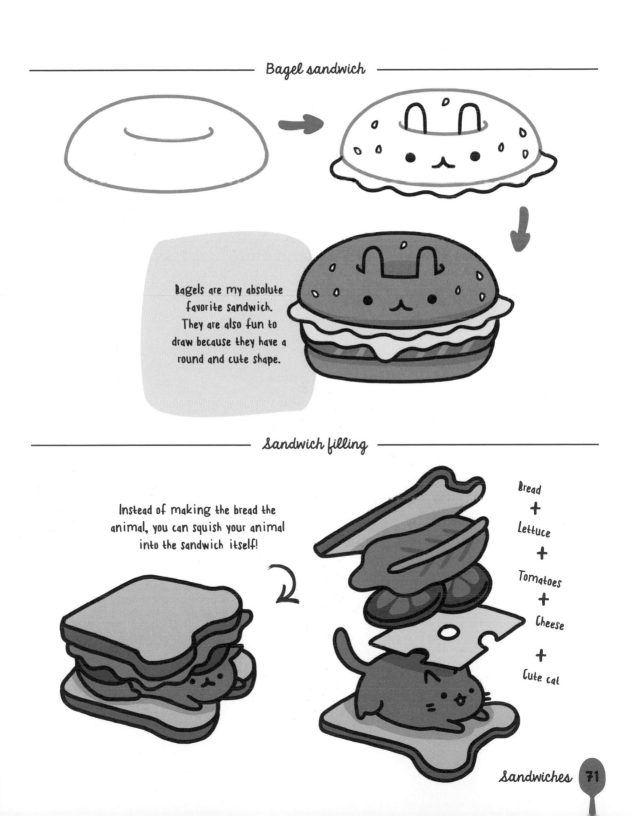

Bagel sandwich

Bagels are my absolute favorite sandwich. They are also fun to draw because they have a round and cute shape.

Sandwich filling

Instead of making the bread the animal, you can squish your animal into the sandwich itself!

Bread
+
Lettuce
+
Tomatoes
+
Cheese
+
Cute cat

HOTPOTS

Half pot

The base of any pot is a circle. Make it a big one so lots of animals can swim in it.

Divide the circle in half so you can have two different broths in one pot. The swimming animals begin life as smaller circles.

Add the details, like ears and legs.

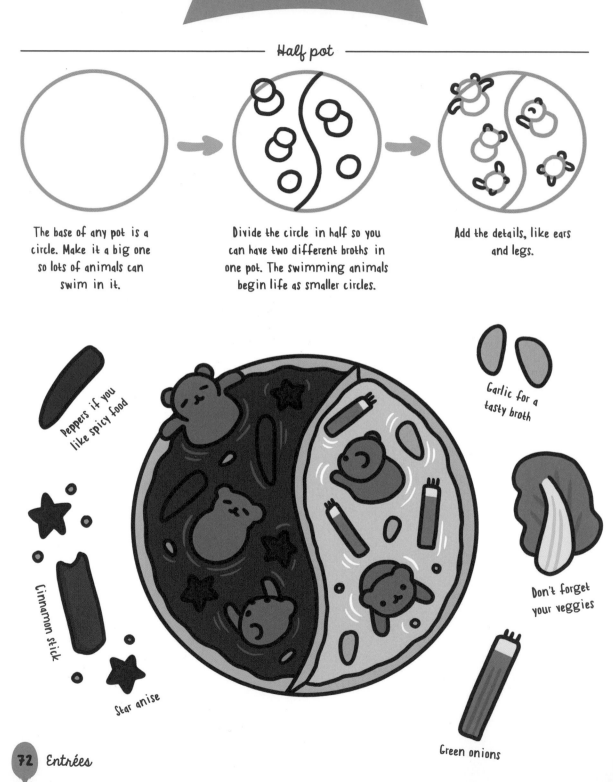

Peppers if you like spicy food

Garlic for a tasty broth

Cinnamon stick

Don't forget your veggies

Star anise

Green onions

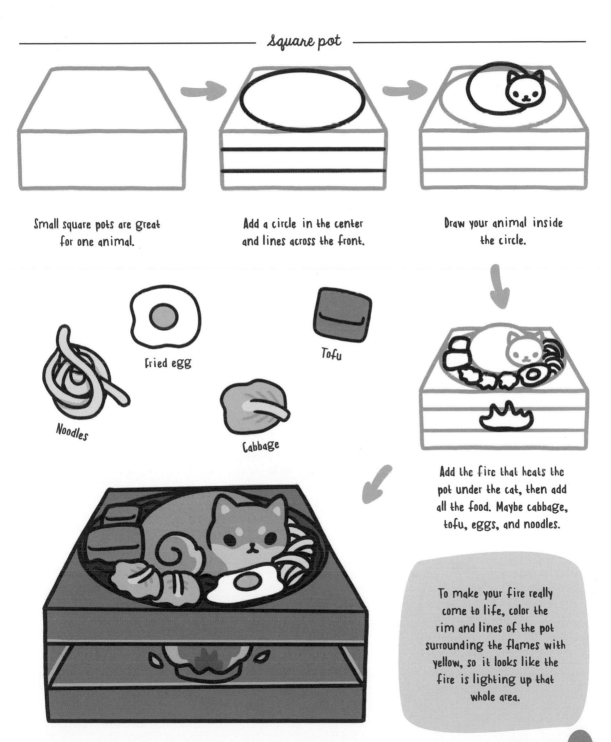

Small square pots are great for one animal.

Add a circle in the center and lines across the front.

Draw your animal inside the circle.

Fried egg

Tofu

Noodles

Cabbage

Add the fire that heats the pot under the cat, then add all the food. Maybe cabbage, tofu, eggs, and noodles.

To make your fire really come to life, color the rim and lines of the pot surrounding the flames with yellow, so it looks like the fire is lighting up that whole area.

EGGS

Hard-boiled egg

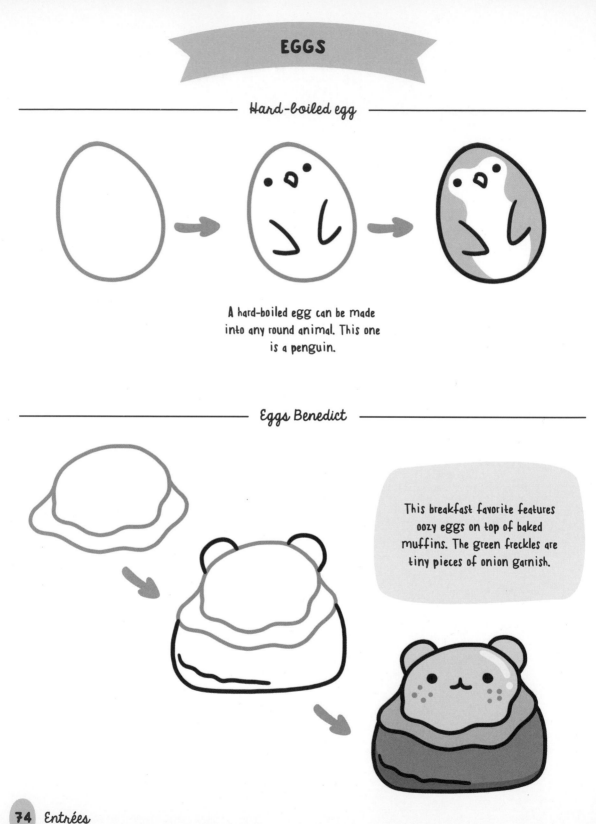

A hard-boiled egg can be made
into any round animal. This one
is a penguin.

Eggs Benedict

This breakfast favorite features
oozy eggs on top of baked
muffins. The green freckles are
tiny pieces of onion garnish.

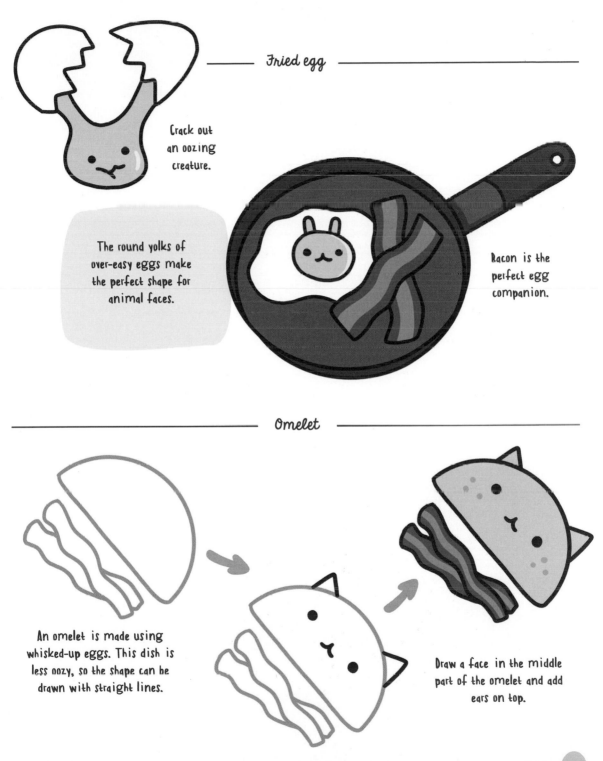

Fried egg

Crack out an oozing creature.

The round yolks of over-easy eggs make the perfect shape for animal faces.

Bacon is the perfect egg companion.

Omelet

An omelet is made using whisked-up eggs. This dish is less oozy, so the shape can be drawn with straight lines.

Draw a face in the middle part of the omelet and add ears on top.

Noodle bowls

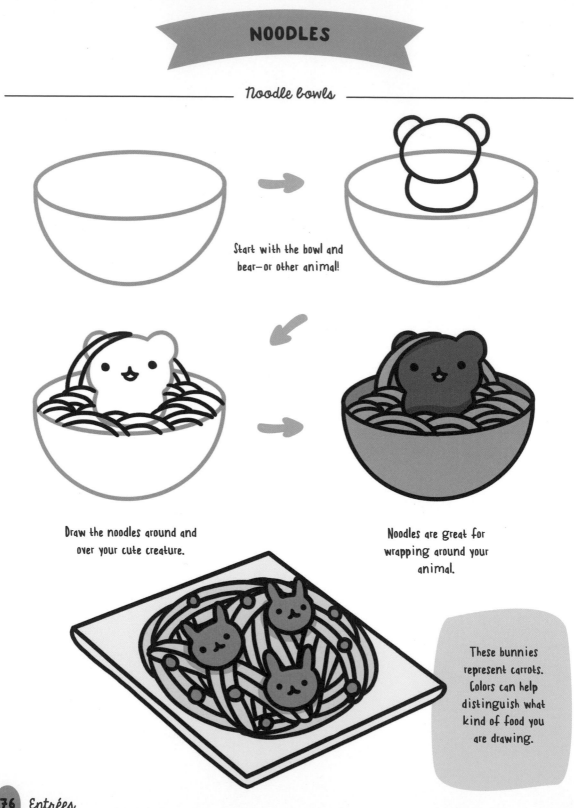

Start with the bowl and
bear—or other animal!

Draw the noodles around and
over your cute creature.

Noodles are great for
wrapping around your
animal.

These bunnies
represent carrots.
Colors can help
distinguish what
kind of food you
are drawing.

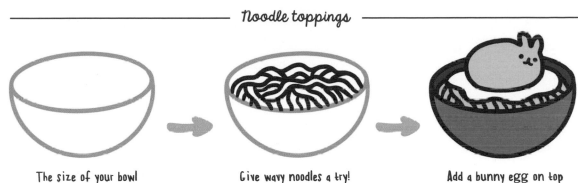

The size of your bowl will determine how many ingredients you can fit into it.

Give wavy noodles a try! Repeat this pattern to fill the bowl.

Add a bunny egg on top of your noodles.

The choice of toppings for your noodle bowls is endless! Here's a dish I enjoy; it has cucumber slices, basil leaves, and grated carrots—oh, and a sleeping cat, of course!

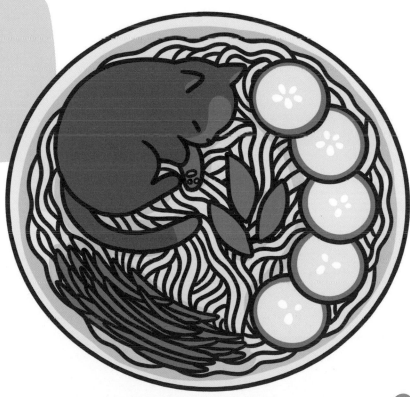

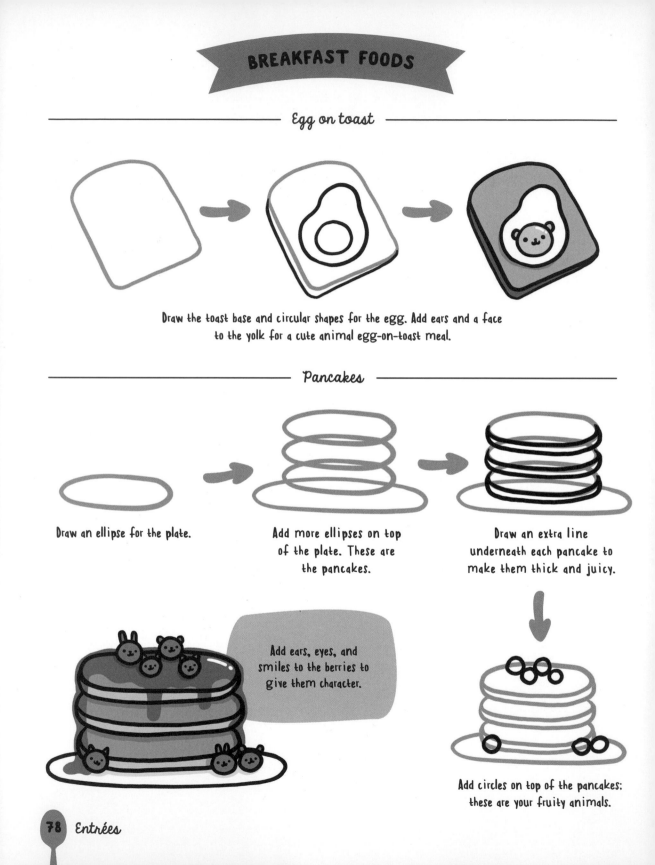

BREAKFAST FOODS

Egg on toast

Draw the toast base and circular shapes for the egg. Add ears and a face to the yolk for a cute animal egg-on-toast meal.

Pancakes

Draw an ellipse for the plate.

Add more ellipses on top of the plate. These are the pancakes.

Draw an extra line underneath each pancake to make them thick and juicy.

Add ears, eyes, and smiles to the berries to give them character.

Add circles on top of the pancakes; these are your fruity animals.

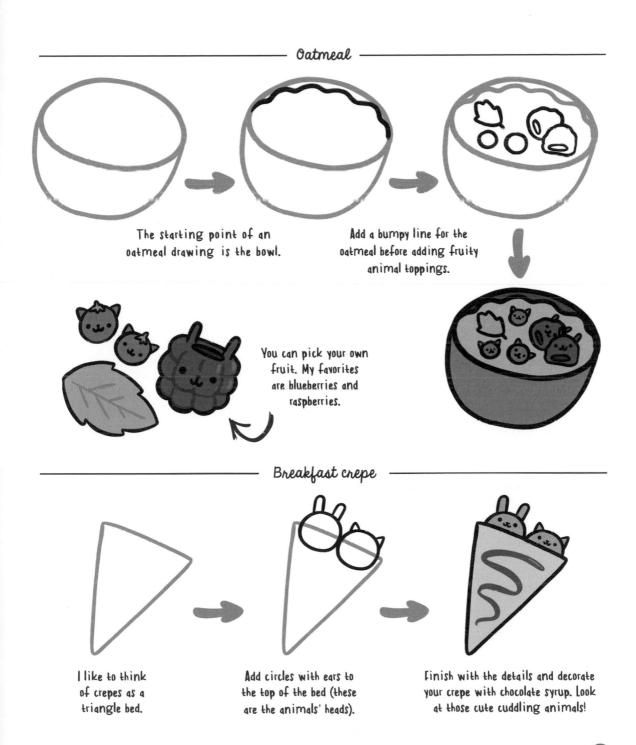

Oatmeal

The starting point of an oatmeal drawing is the bowl.

Add a bumpy line for the oatmeal before adding fruity animal toppings.

You can pick your own fruit. My favorites are blueberries and raspberries.

Breakfast crepe

I like to think of crepes as a triangle bed.

Add circles with ears to the top of the bed (these are the animals' heads).

Finish with the details and decorate your crepe with chocolate syrup. Look at those cute cuddling animals!

Seaweed wraps

Start with the seaweed bed.

Add your animal on top. I chose a cat.

You can also wrap your animal in seaweed. Start by drawing two ovals: the top will be the animal and the bottom will be the rice.

Color and draw your cat based on which kind of sushi you like. I referenced a shrimp to draw this cat!

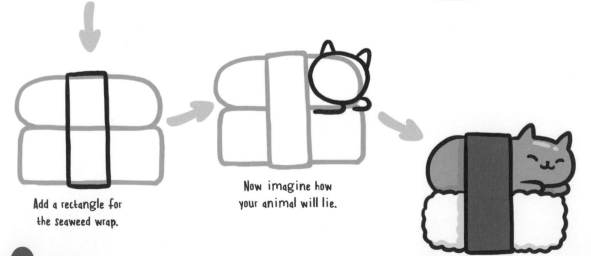

Add a rectangle for the seaweed wrap.

Now imagine how your animal will lie.

Sushi roll

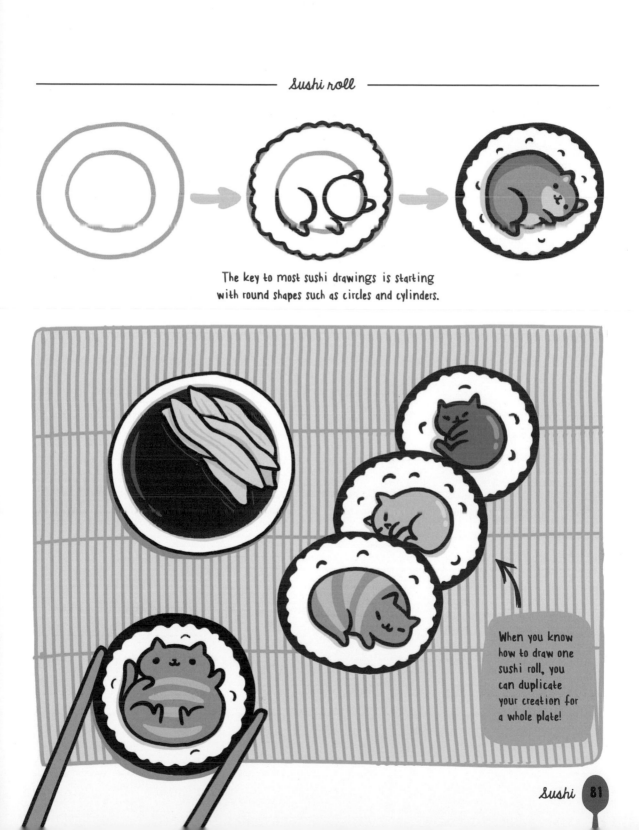

The key to most sushi drawings is starting with round shapes such as circles and cylinders.

When you know how to draw one sushi roll, you can duplicate your creation for a whole plate!

PIZZA

Pizza slice

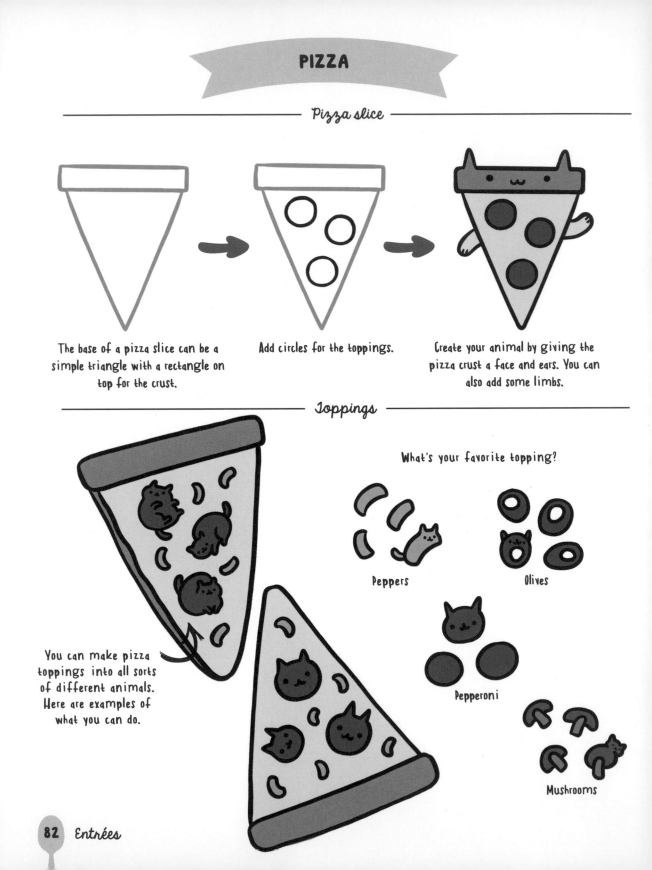

The base of a pizza slice can be a simple triangle with a rectangle on top for the crust.

Add circles for the toppings.

Create your animal by giving the pizza crust a face and ears. You can also add some limbs.

Toppings

What's your favorite topping?

You can make pizza toppings into all sorts of different animals. Here are examples of what you can do.

Peppers

Olives

Pepperoni

Mushrooms

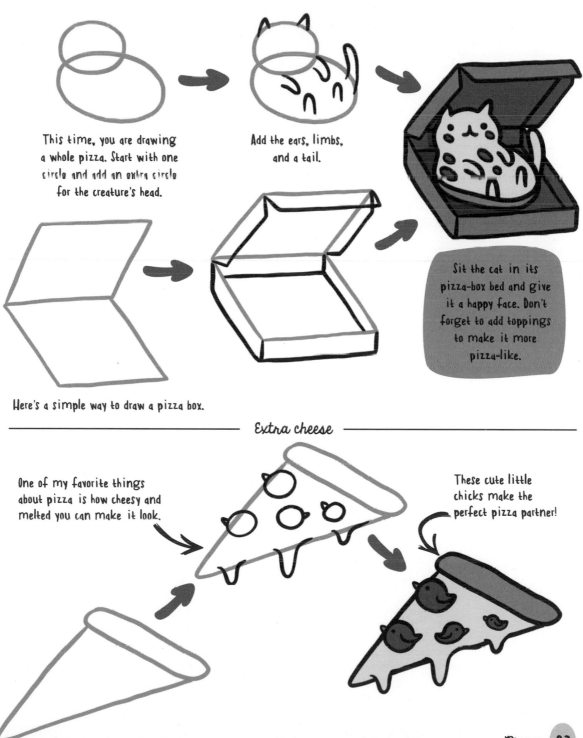

This time, you are drawing a whole pizza. Start with one circle and add an extra circle for the creature's head.

Add the ears, limbs, and a tail.

Sit the cat in its pizza-box bed and give it a happy face. Don't forget to add toppings to make it more pizza-like.

Here's a simple way to draw a pizza box.

Extra cheese

One of my favorite things about pizza is how cheesy and melted you can make it look.

These cute little chicks make the perfect pizza partner!

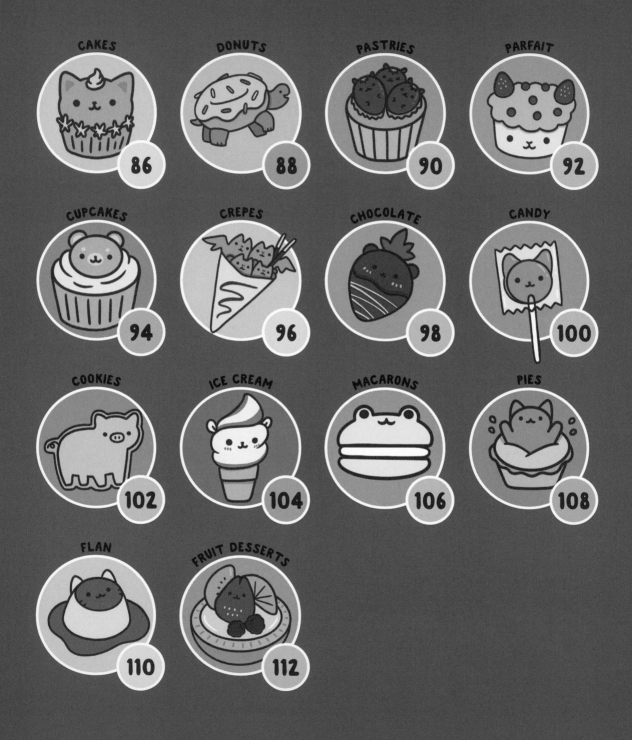

CAKES 86

DONUTS 88

PASTRIES 90

PARFAIT 92

CUPCAKES 94

CREPES 96

CHOCOLATE 98

CANDY 100

COOKIES 102

ICE CREAM 104

MACARONS 106

PIES 108

FLAN 110

FRUIT DESSERTS 112

Chapter four

DESSERTS AND SWEET TREATS

The animals in this chapter love their sweet treats, whether that's candy, cookies, cakes, or crepes.

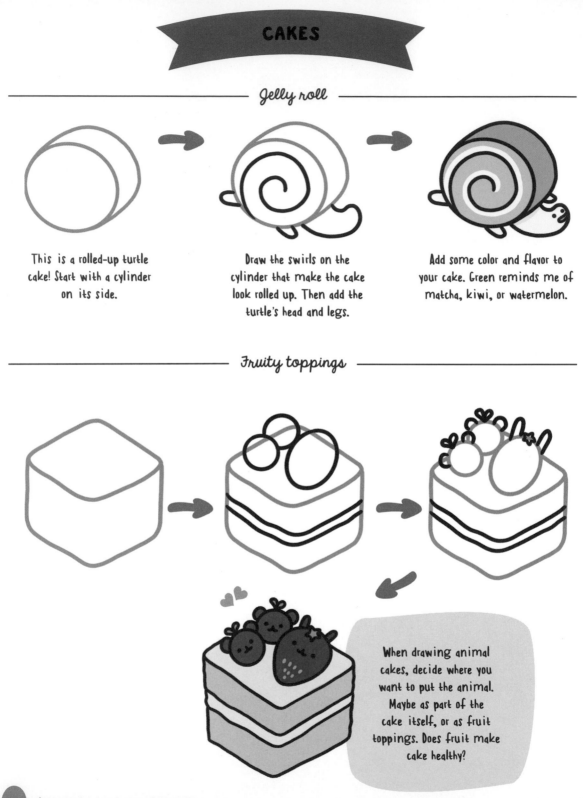

CAKES

Jelly roll

This is a rolled-up turtle cake! Start with a cylinder on its side.

Draw the swirls on the cylinder that make the cake look rolled up. Then add the turtle's head and legs.

Add some color and flavor to your cake. Green reminds me of matcha, kiwi, or watermelon.

Fruity toppings

When drawing animal cakes, decide where you want to put the animal. Maybe as part of the cake itself, or as fruit toppings. Does fruit make cake healthy?

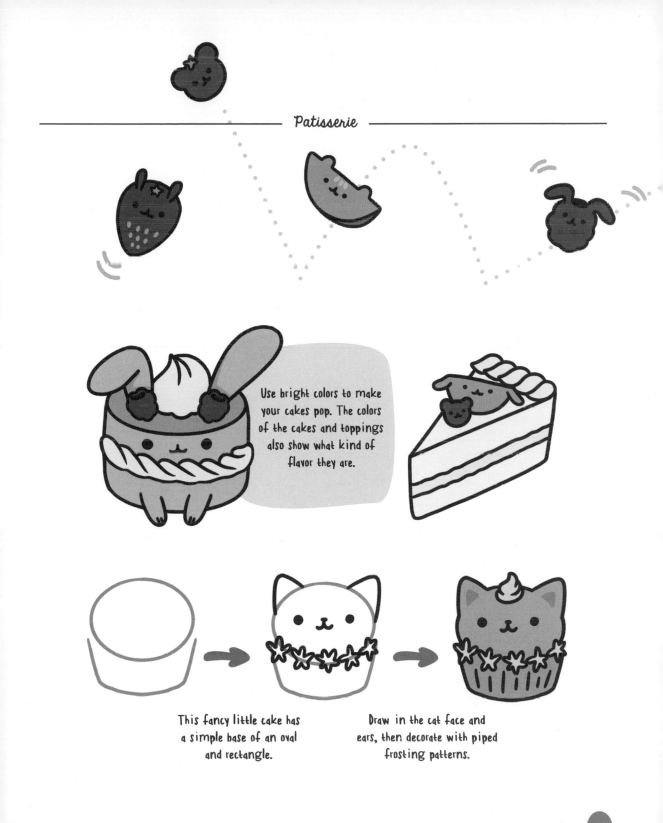

Use bright colors to make your cakes pop. The colors of the cakes and toppings also show what kind of flavor they are.

This fancy little cake has a simple base of an oval and rectangle.

Draw in the cat face and ears, then decorate with piped frosting patterns.

DONUTS

Glazed donuts

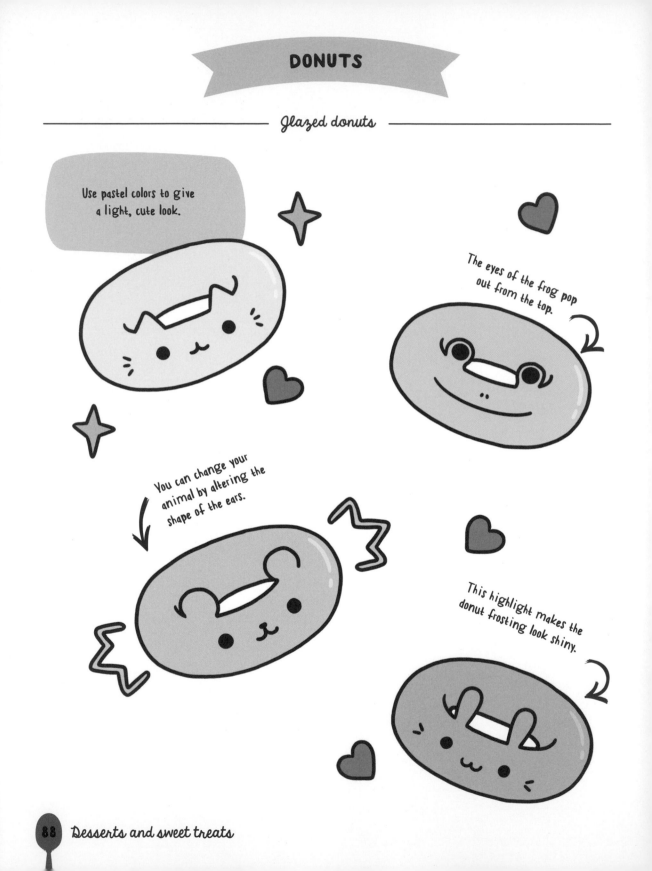

Use pastel colors to give a light, cute look.

The eyes of the frog pop out from the top.

You can change your animal by altering the shape of the ears.

This highlight makes the donut frosting look shiny.

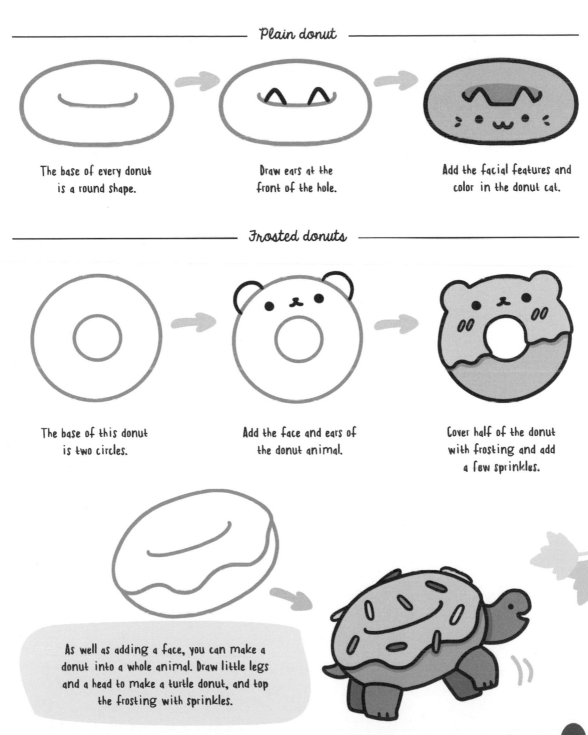

Plain donut

The base of every donut is a round shape.

Draw ears at the front of the hole.

Add the facial features and color in the donut cat.

Frosted donuts

The base of this donut is two circles.

Add the face and ears of the donut animal.

Cover half of the donut with frosting and add a few sprinkles.

As well as adding a face, you can make a donut into a whole animal. Draw little legs and a head to make a turtle donut, and top the frosting with sprinkles.

PASTRIES

Pastry roll

The base of a wrapped pastry is a cylinder. Add a circle where the face will go.

Draw ears, curved lines on the cylinder for the pastry creases, and a wobbly line for the shape of the tail.

Don't forget to color in the dark shades around the lemur's eyes and nose.

Pastry buns

Buns can have cute faces, or be oozing with adorable animals.

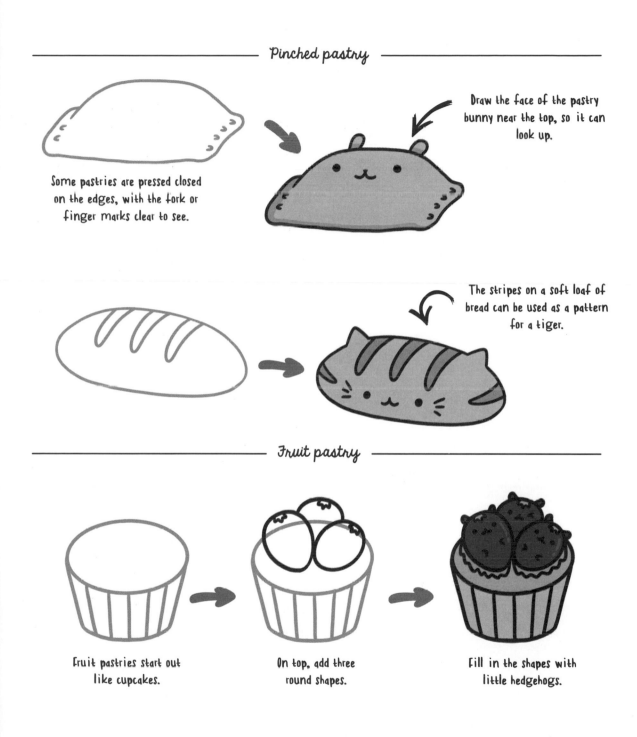

Pinched pastry

Some pastries are pressed closed on the edges, with the fork or finger marks clear to see.

Draw the face of the pastry bunny near the top, so it can look up.

The stripes on a soft loaf of bread can be used as a pattern for a tiger.

Fruit pastry

Fruit pastries start out like cupcakes.

On top, add three round shapes.

Fill in the shapes with little hedgehogs.

PARFAIT

Strawberry parfait

Begin the base drawing with a container and some circles.

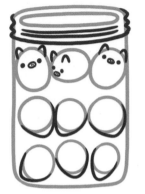

The circles will represent strawberries and little piggies. Add some curved lines for the detail around the top of the jar.

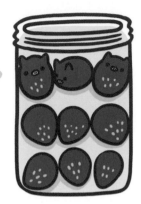

Color the piggies red and add yellow seeds to each fruit.

Containers

Put your parfait in any kind of container you choose. Maybe a simple bowl with a cute little face . . .

. . . or a round cup-shaped container?

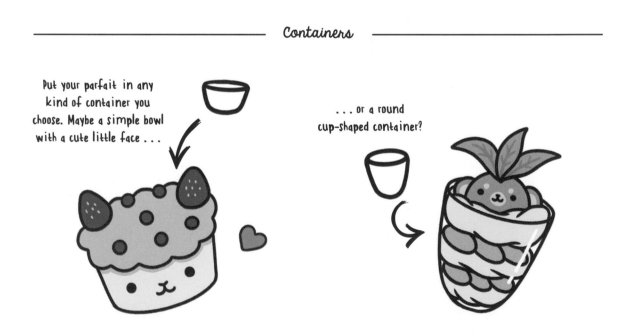

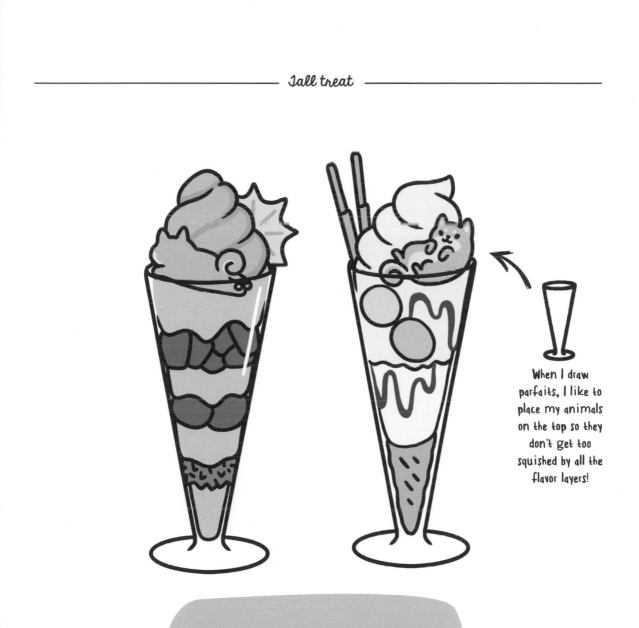

When I draw parfaits, I like to place my animals on the top so they don't get too squished by all the flavor layers!

Your parfait layers might include ice cream, fruit, nuts, whipped cream, and more. The possibilities are endless!

— *Fancy cupcake* —

Think of cupcakes as two parts: the frosting top and the wrapper bottom.

Add details to the frosting and wrapping, and a shape for your animal.

Add sprinkles to the frosting and details to the animal.

What's your favorite cupcake flavor? The colors you choose will determine what flavor you've drawn. This one is obviously chocolate!

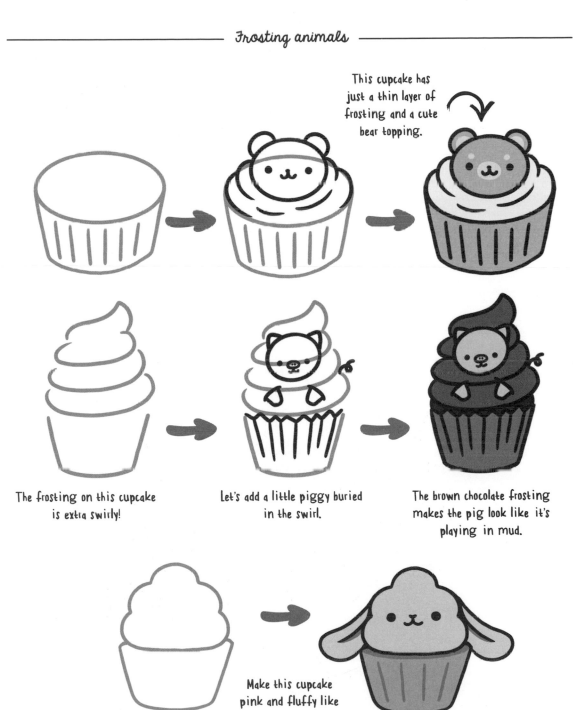

This cupcake has just a thin layer of frosting and a cute bear topping.

The frosting on this cupcake is extra swirly!

Let's add a little piggy buried in the swirl.

The brown chocolate frosting makes the pig look like it's playing in mud.

Make this cupcake pink and fluffy like a cute sheep.

CREPES

Folded crepe

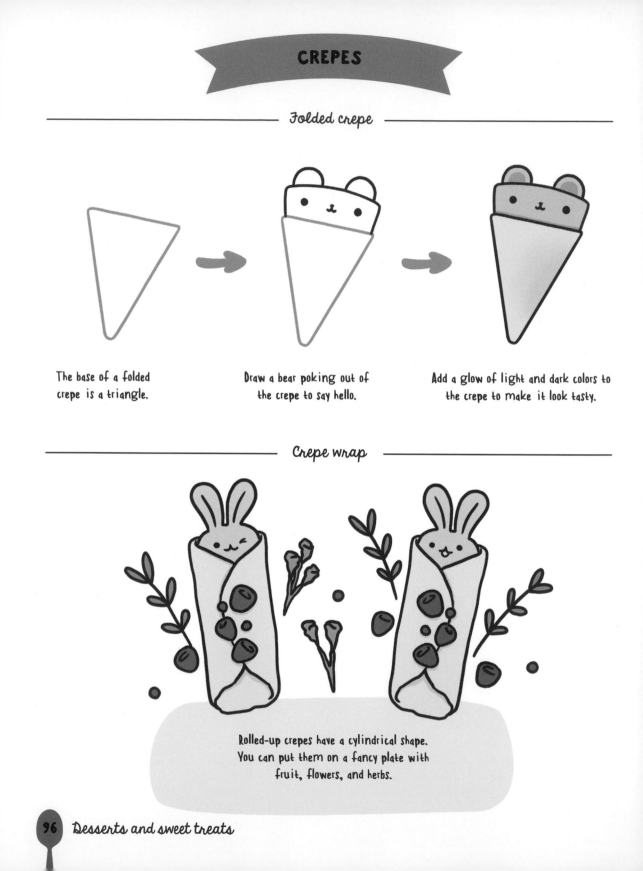

The base of a folded crepe is a triangle.

Draw a bear poking out of the crepe to say hello.

Add a glow of light and dark colors to the crepe to make it look tasty.

Crepe wrap

Rolled-up crepes have a cylindrical shape. You can put them on a fancy plate with fruit, flowers, and herbs.

Desserts and sweet treats

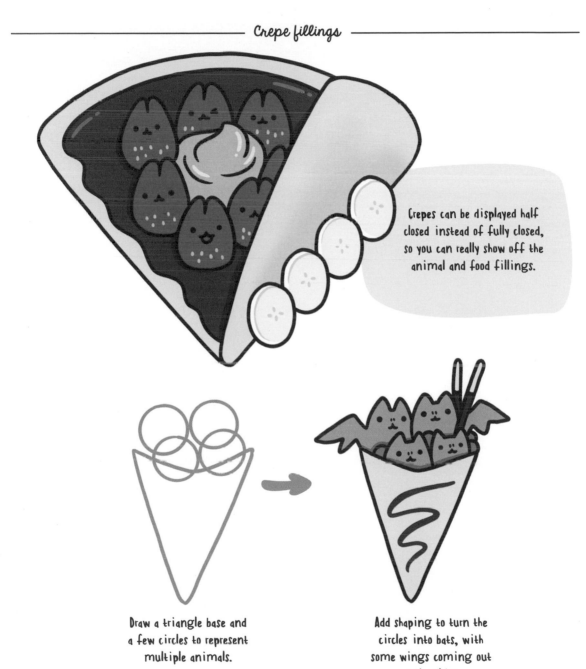

Crepes can be displayed half closed instead of fully closed, so you can really show off the animal and food fillings.

Draw a triangle base and a few circles to represent multiple animals.

Add shaping to turn the circles into bats, with some wings coming out at the sides.

Chocolate bar

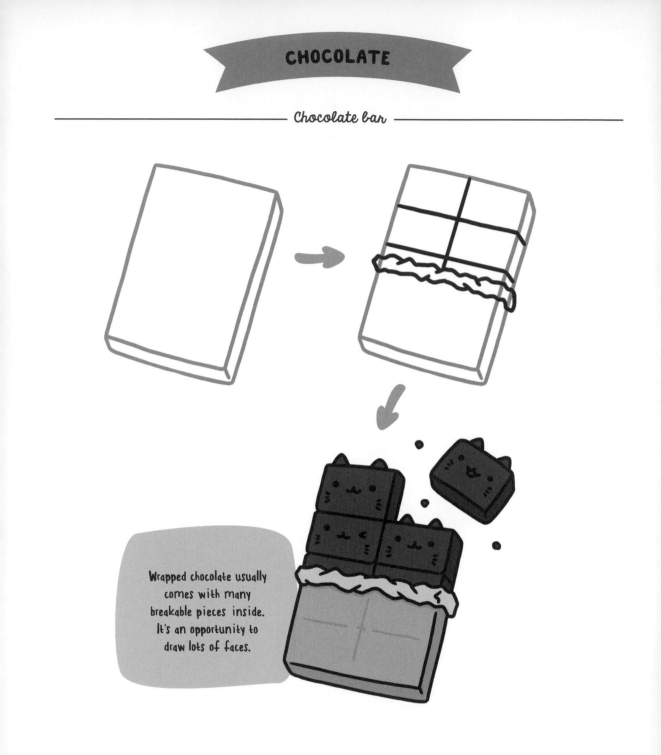

Wrapped chocolate usually comes with many breakable pieces inside. It's an opportunity to draw lots of faces.

A small piece of chocolate
makes a cute little animal.

Draw the face and other
features on one side.

Add a shine highlight at the
back to make a tempting,
scrumptious chocolate piece.

Chocolate animals

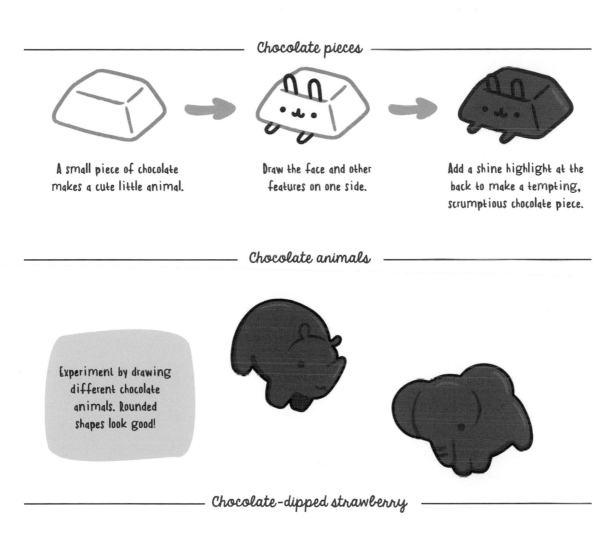

Experiment by drawing
different chocolate
animals. Rounded
shapes look good!

Chocolate-dipped strawberry

Start with a basic
strawberry shape.

Add a wavy line to
indicate a coating of
dipped chocolate.

Add zigzags to the chocolate
for a fancy effect.

CANDY

Lollipop

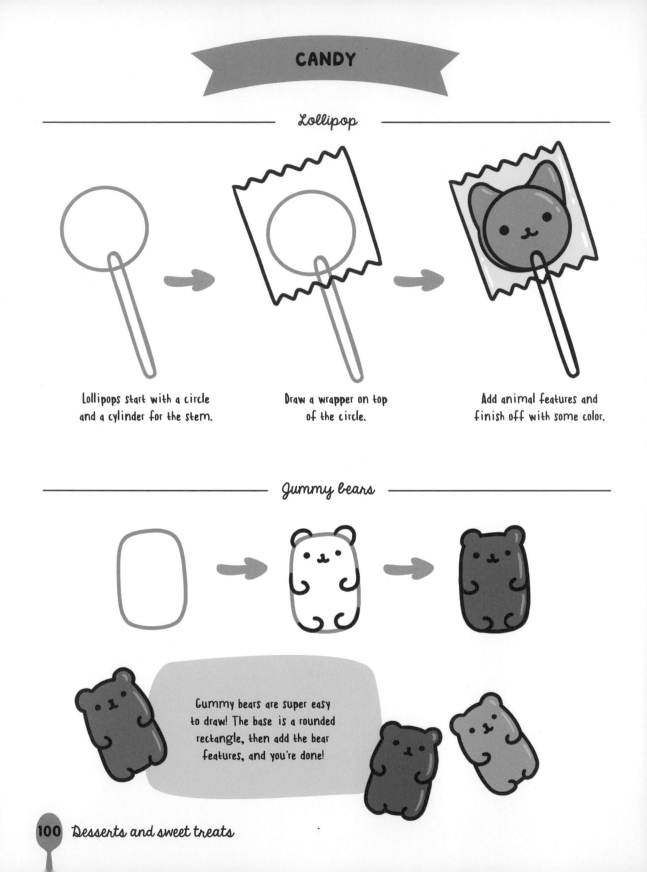

Lollipops start with a circle and a cylinder for the stem.

Draw a wrapper on top of the circle.

Add animal features and finish off with some color.

Gummy bears

Gummy bears are super easy to draw! The base is a rounded rectangle, then add the bear features, and you're done!

Wrapped candy

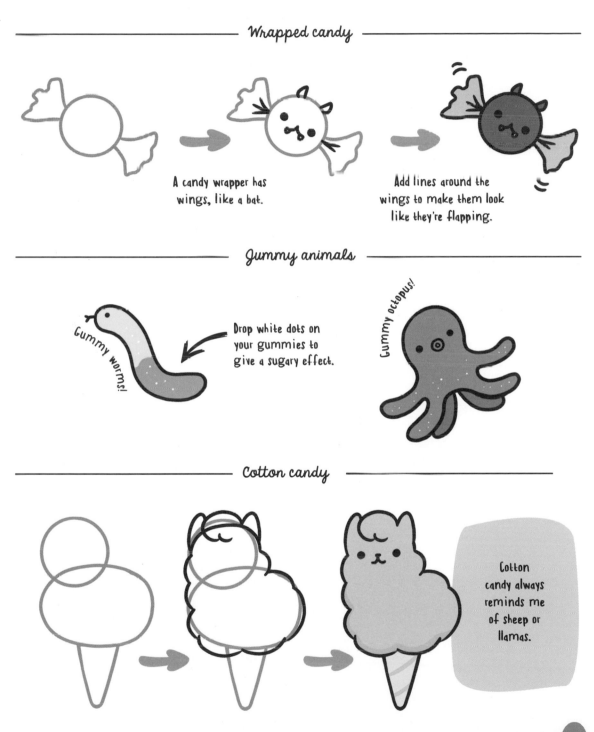

A candy wrapper has wings, like a bat.

Add lines around the wings to make them look like they're flapping.

Gummy animals

Gummy worms!

Drop white dots on your gummies to give a sugary effect.

Gummy octopus!

Cotton candy

Cotton candy always reminds me of sheep or llamas.

COOKIES

Frosted cookies

These types of cookies are a two-step drawing process. Step 1: Draw the animal silhouette. Step 2: Draw the animal details inside the silhouette.

The base of the cookie is the animal silhouette. This one is a chicken.

Draw an inner silhouette. This will be the cookie frosting.

Color in the frosting (inside layer) and then the cookie (outside layer).

Frosting details

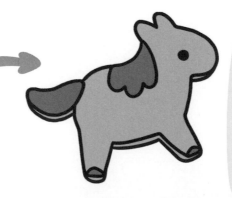

Frosting doesn't have to cover the entire cookie. Here's a horse cookie with frosting only on the mane, tail, and hooves.

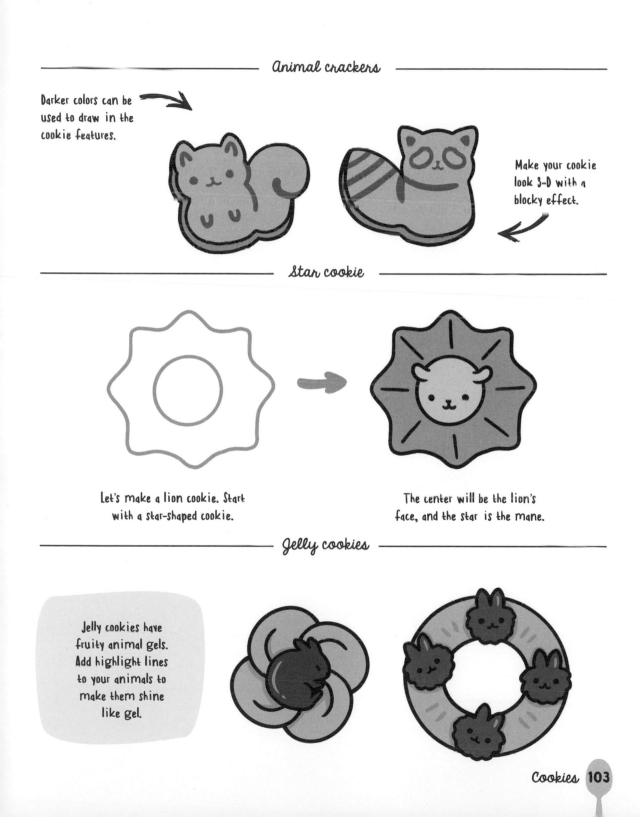

Animal crackers

Darker colors can be used to draw in the cookie features.

Make your cookie look 3-D with a blocky effect.

Star cookie

Let's make a lion cookie. Start with a star-shaped cookie.

The center will be the lion's face, and the star is the mane.

Jelly cookies

Jelly cookies have fruity animal gels. Add highlight lines to your animals to make them shine like gel.

— *Ice-cream cones* —

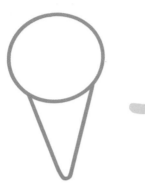

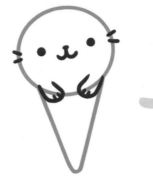

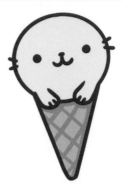

This is a really easy starting point: a circle on top of a triangle.

Draw in the animal details. This one is a seal.

Color in the seal and the lines for the waffle cone.

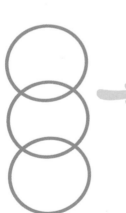

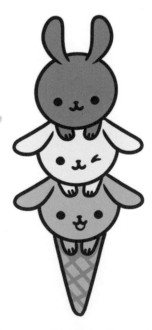

Try an ice cream cone with stacked flavors. Draw multiple circles that overlap slightly.

Draw in the cone and animal ears.

I've made a Neapolitan flavor mix—chocolate, vanilla, and strawberry.

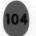

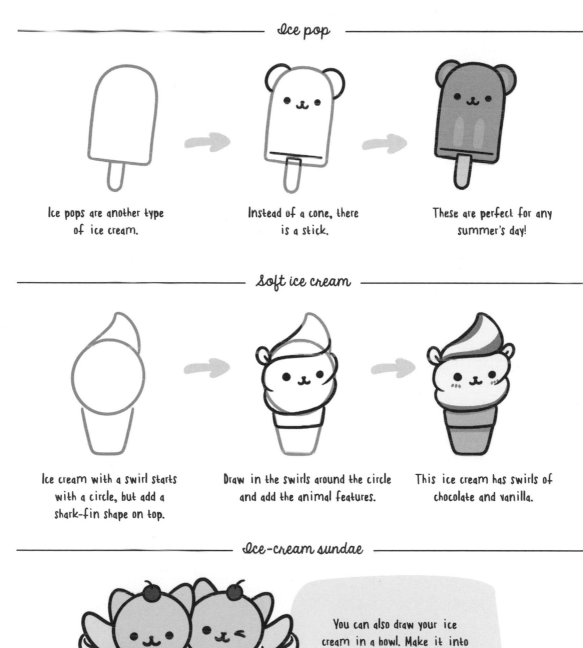

Ice pop

Ice pops are another type of ice cream.

Instead of a cone, there is a stick.

These are perfect for any summer's day!

Soft ice cream

Ice cream with a swirl starts with a circle, but add a shark-fin shape on top.

Draw in the swirls around the circle and add the animal features.

This ice cream has swirls of chocolate and vanilla.

Ice-cream sundae

You can also draw your ice cream in a bowl. Make it into a sundae by adding toppings like cherries and bananas.

MACARONS

Animal buns

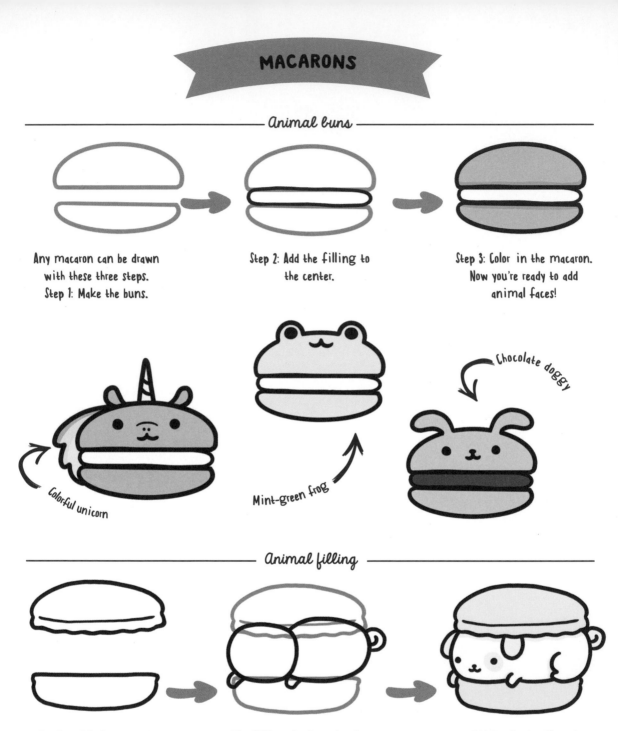

Any macaron can be drawn with these three steps.
Step 1: Make the buns.

Step 2: Add the filling to the center.

Step 3: Color in the macaron. Now you're ready to add animal faces!

Colorful unicorn

Mint-green frog

Chocolate doggy

Animal filling

Begin with the top and bottom buns.

The filling is the animal. Add a circle for the head and body, then limbs and a tail.

Add in the details and you've got yourself a doggy macaron.

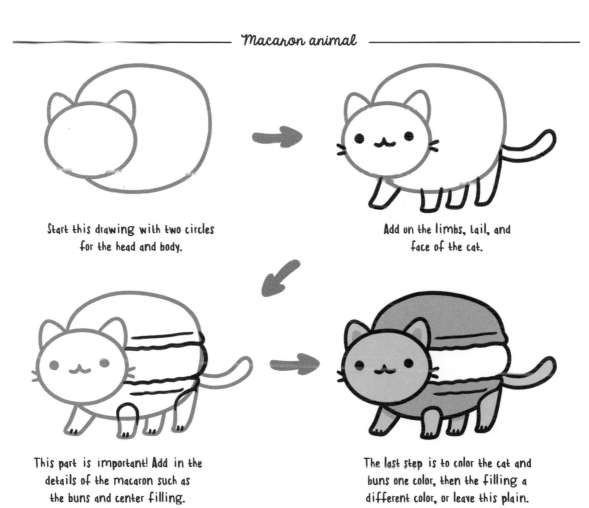

Start this drawing with two circles
for the head and body.

Add on the limbs, tail, and
face of the cat.

This part is important! Add in the
details of the macaron such as
the buns and center filling.

The last step is to color the cat and
buns one color, then the filling a
different color, or leave this plain.

Macaron tops

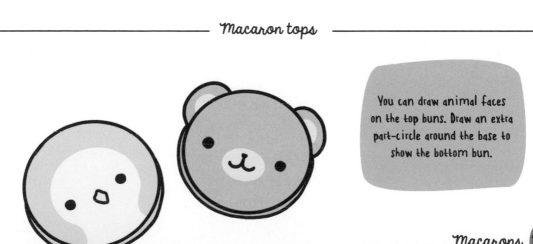

You can draw animal faces
on the top buns. Draw an extra
part-circle around the base to
show the bottom bun.

PIES

Fruit pies

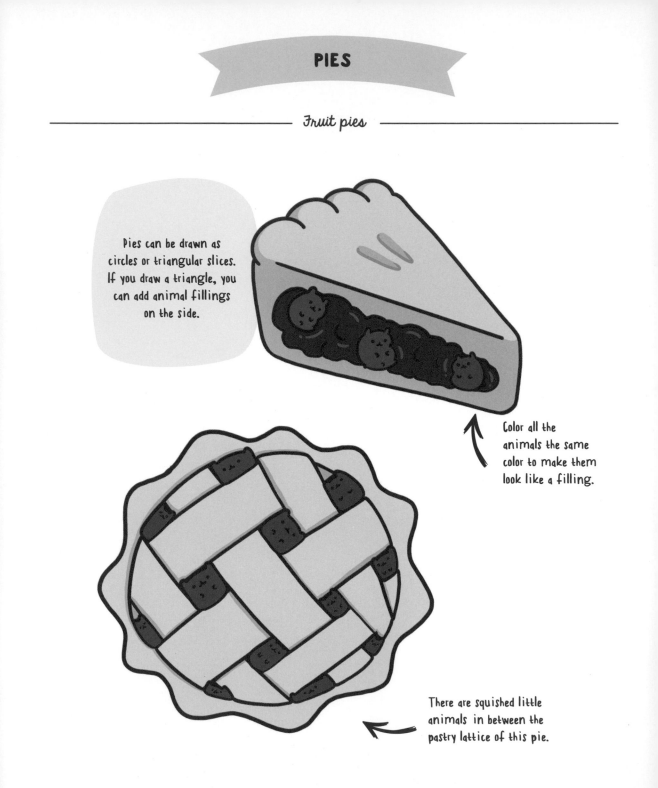

Pies can be drawn as circles or triangular slices. If you draw a triangle, you can add animal fillings on the side.

Color all the animals the same color to make them look like a filling.

There are squished little animals in between the pastry lattice of this pie.

Animal topping

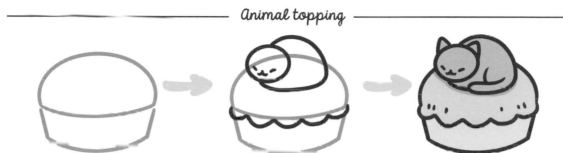

The base of this pie is a semicircle and rounded rectangle.

Add a wavy line for the pastry frill and an animal sleeping on top.

Notice how the cat is a similar shape to the pie. They're both round and cute.

Pasrty animal

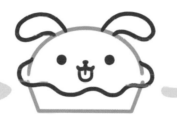
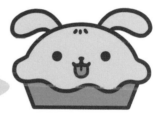

Start with a base made of simple lines.

Draw the animal face and ears on your base. Draw a wavy line for the bottom of the pastry.

Here's a dog pie face!

Animal filling

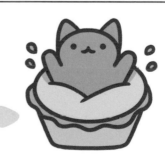

So that we can see the whole of the pie top, this time draw a full circle and the wavy pastry line.

An animal can pop out of the center of the pie.

Draw little bits of pie flying out from the sides to make the drawing really pop.

FLAN

Caramel dessert

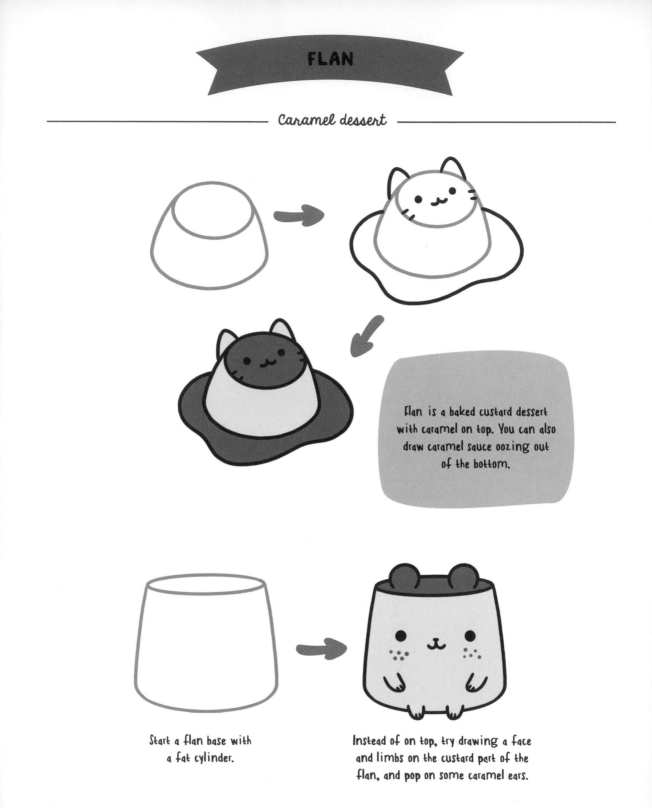

Flan is a baked custard dessert with caramel on top. You can also draw caramel sauce oozing out of the bottom.

Start a flan base with a fat cylinder.

Instead of on top, try drawing a face and limbs on the custard part of the flan, and pop on some caramel ears.

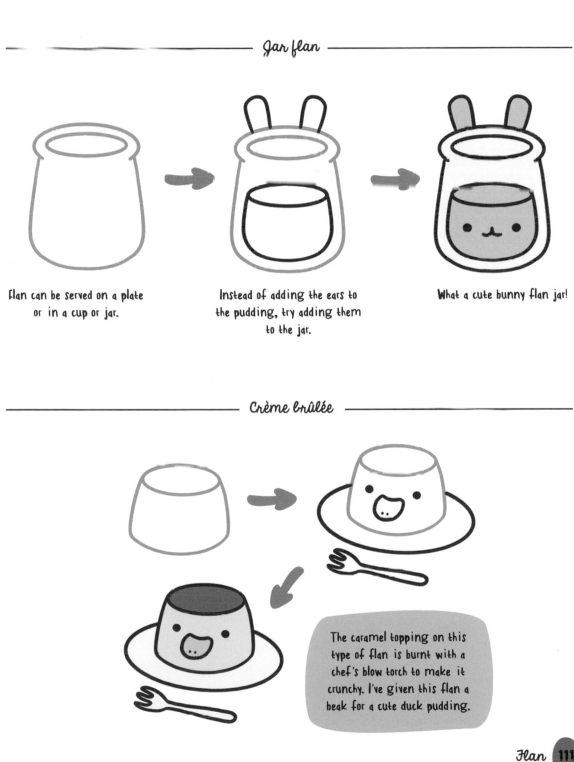

Jar flan

Flan can be served on a plate or in a cup or jar.

Instead of adding the ears to the pudding, try adding them to the jar.

What a cute bunny flan jar!

Crème brûlée

The caramel topping on this type of flan is burnt with a chef's blow torch to make it crunchy. I've given this flan a beak for a cute duck pudding.

FRUIT DESSERTS

Chocolate-dipped fruit

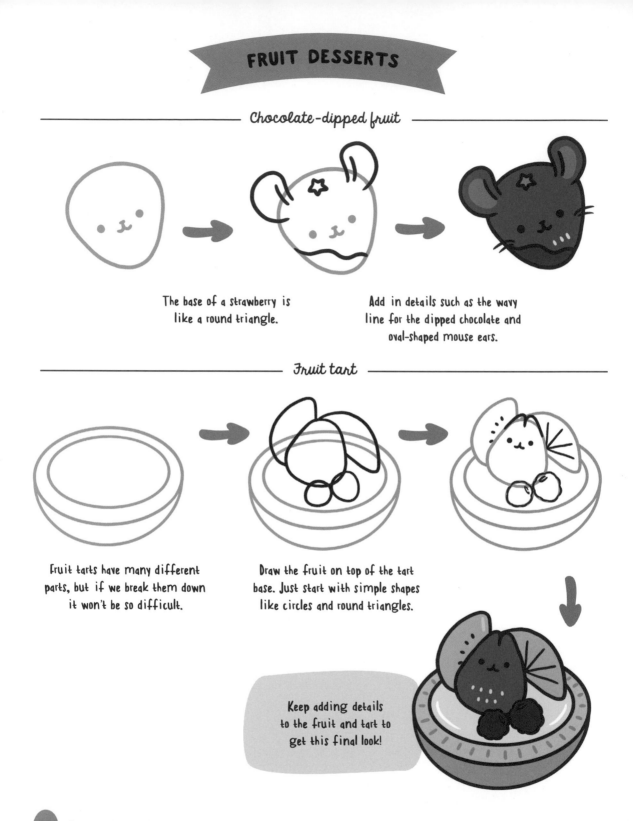

The base of a strawberry is like a round triangle.

Add in details such as the wavy line for the dipped chocolate and oval-shaped mouse ears.

Fruit tart

Fruit tarts have many different parts, but if we break them down it won't be so difficult.

Draw the fruit on top of the tart base. Just start with simple shapes like circles and round triangles.

Keep adding details to the fruit and tart to get this final look!

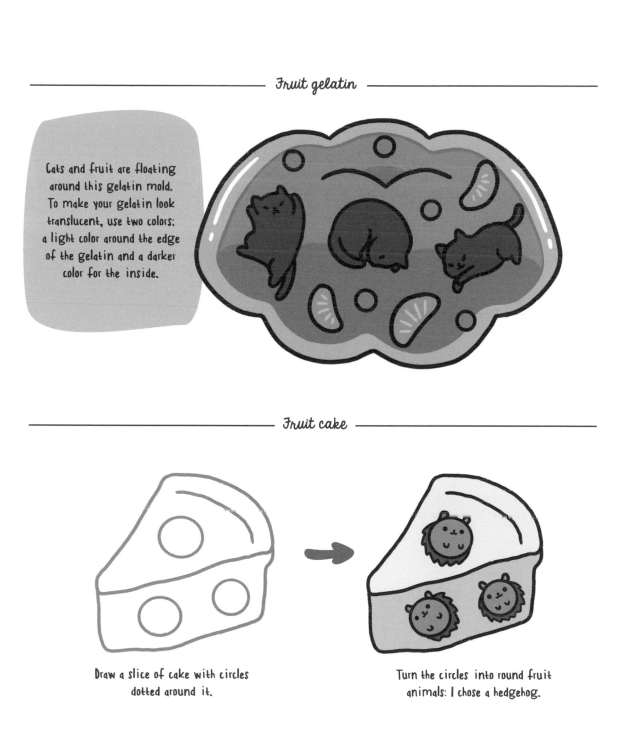

Fruit gelatin

Cats and fruit are floating around this gelatin mold. To make your gelatin look translucent, use two colors: a light color around the edge of the gelatin and a darker color for the inside.

Fruit cake

Draw a slice of cake with circles dotted around it.

Turn the circles into round fruit animals: I chose a hedgehog.

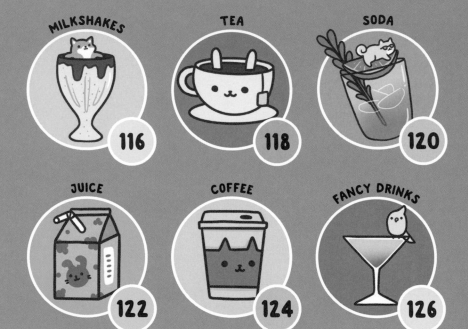

MILKSHAKES 116

TEA 118

SODA 120

JUICE 122

COFFEE 124

FANCY DRINKS 126

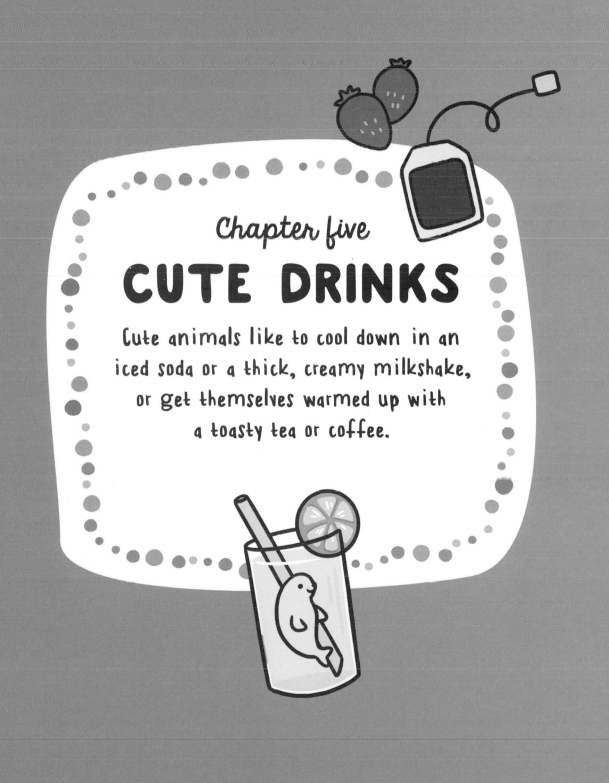

Chapter five

CUTE DRINKS

Cute animals like to cool down in an
iced soda or a thick, creamy milkshake,
or get themselves warmed up with
a toasty tea or coffee.

MILKSHAKES

There are various ways to add animals to milkshakes. The animal could be on top, floating inside, or even the cup itself.

Start drawing frosting with a semicircle, then add in the curvy lines on top.

Turn any mug into an animal! Imagine having a mug and then adding the head, limbs, and tail.

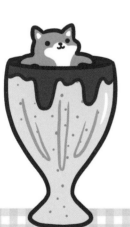

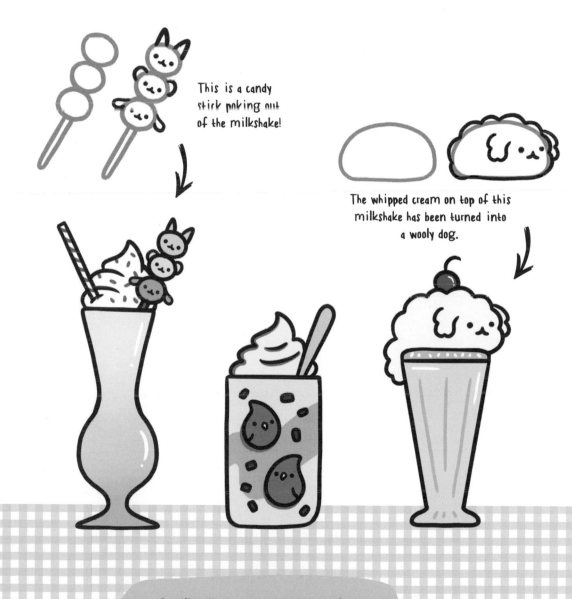

This is a candy stick poking out of the milkshake!

The whipped cream on top of this milkshake has been turned into a wooly dog.

A milkshake is a sweet drink made from milk and ice cream. There are many toppings and syrups that can be added to make an even sweeter flavor and a pretty drink.

TEA

Cup of tea

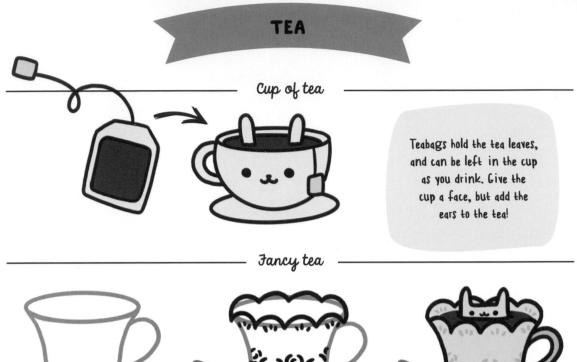

Teabags hold the tea leaves, and can be left in the cup as you drink. Give the cup a face, but add the ears to the tea!

Fancy tea

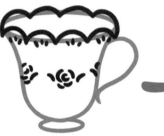 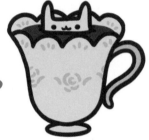

Let's draw a fancy teacup. Remember to make it very curvy.

Add in the dainty details, such as floral designs or little curved lines.

The final touch is a little animal relaxing in the warm drink.

Bubble tea

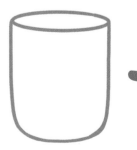 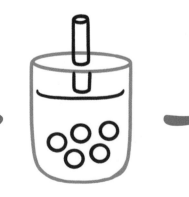 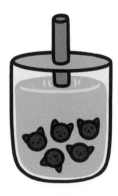

Bubble tea is a combination of milk and tea.

Bubble tea contains chewy additions called boba.

The boba can be given animal features.

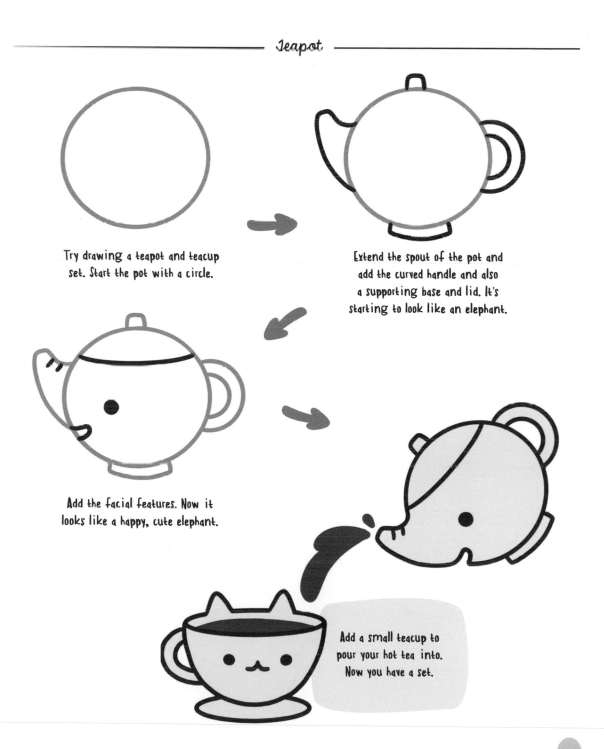

Try drawing a teapot and teacup set. Start the pot with a circle.

Extend the spout of the pot and add the curved handle and also a supporting base and lid. It's starting to look like an elephant.

Add the facial features. Now it looks like a happy, cute elephant.

Add a small teacup to pour your hot tea into. Now you have a set.

SODA

Soda can

 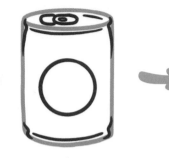

The base for a soda can is a cylinder.

Add in the details of the can, such as the pull tab on top.

Draw in the design of your can. Make the animal face big and cute in front.

Soda bottle

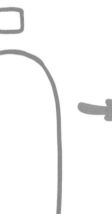 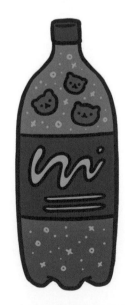

Soda bottles are also cylindrical.

Draw the details on the bottle, such as the bottom curves that hold up the bottle.

Add in your own bubble motifs and include some happy floating animal faces.

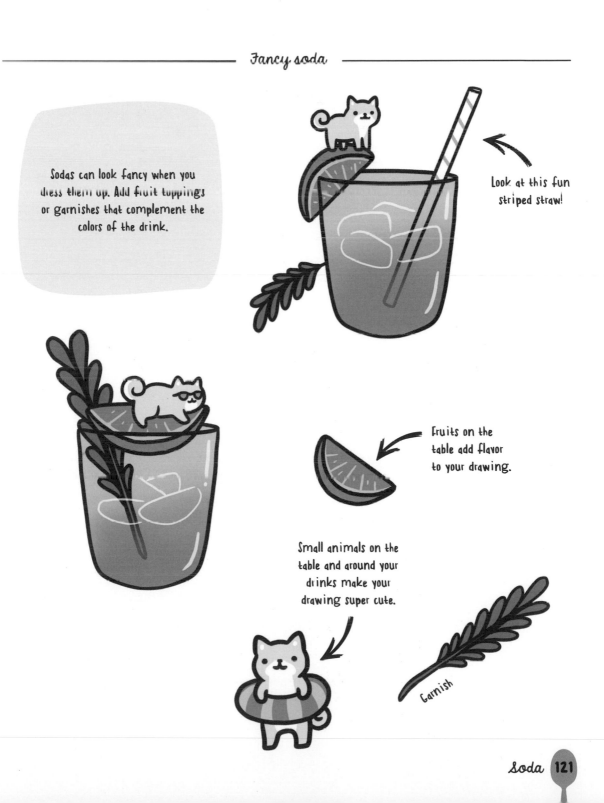

Sodas can look fancy when you dress them up. Add fruit toppings or garnishes that complement the colors of the drink.

Look at this fun striped straw!

Fruits on the table add flavor to your drawing.

Small animals on the table and around your drinks make your drawing super cute.

Garnish

JUICE

Juice box

A juice box kind of looks like a small house.

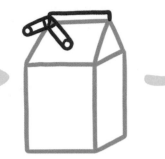

Draw in a bent straw to complete the juice-box look.

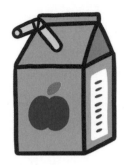

This last part is up to you. What flavor do you want to color your juice box?

Pineapple cat

Peach deer

Grape bunny

Orange rabbit

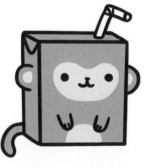

Juice boxes come in many shapes and sizes. You can draw your animal on the box or make the box itself into an animal, like this monkey.

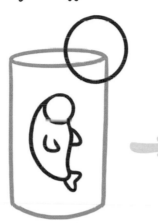

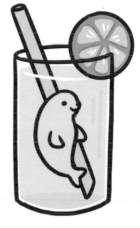

Let's draw our juice in a glass instead of a box.

Draw the base shape of a seal inside the glass. Add a circle to the edge for the fruit decoration.

Color in your glass of fruit juice. This is a refreshing pineapple juice for a hot day.

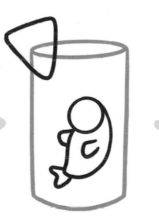

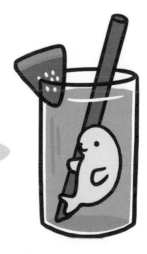

This time, add a triangle on the edge of the glass for a watermelon garnish.

Color in the drawing with bright pink colors and add the details to the watermelon slice.

COFFEE

Coffee to go

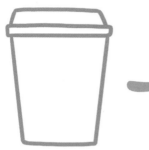 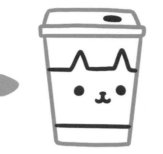 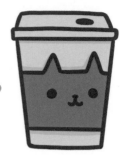

Draw a take-out coffee cup.

Add a sleeve around the cup. This protects you from the hot contents.

Color in your cute animal sleeve and coffee cup.

Latte art

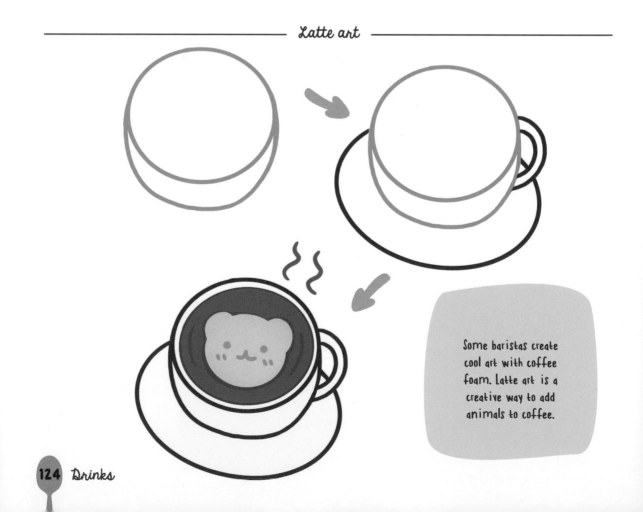

Some baristas create cool art with coffee foam. Latte art is a creative way to add animals to coffee.

3-D latte art

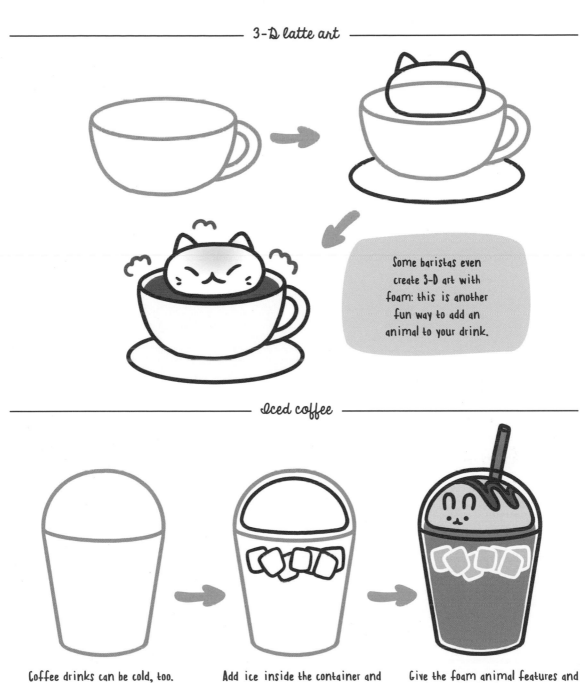

Some baristas even create 3-D art with foam: this is another fun way to add an animal to your drink.

Iced coffee

Coffee drinks can be cold, too.

Add ice inside the container and foam on top of the coffee.

Give the foam animal features and add caramel sauce and a straw.

FANCY DRINKS

Fancy glass

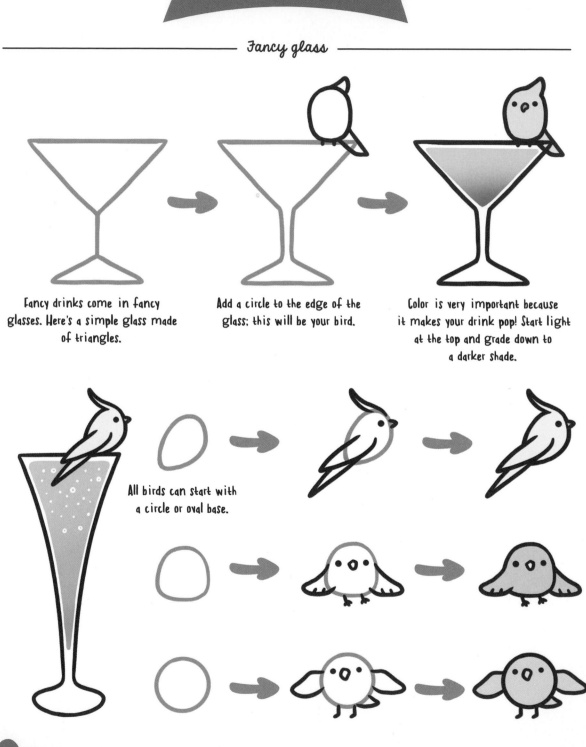

Fancy drinks come in fancy glasses. Here's a simple glass made of triangles.

Add a circle to the edge of the glass; this will be your bird.

Color is very important because it makes your drink pop! Start light at the top and grade down to a darker shade.

All birds can start with a circle or oval base.

Fancy lemonade

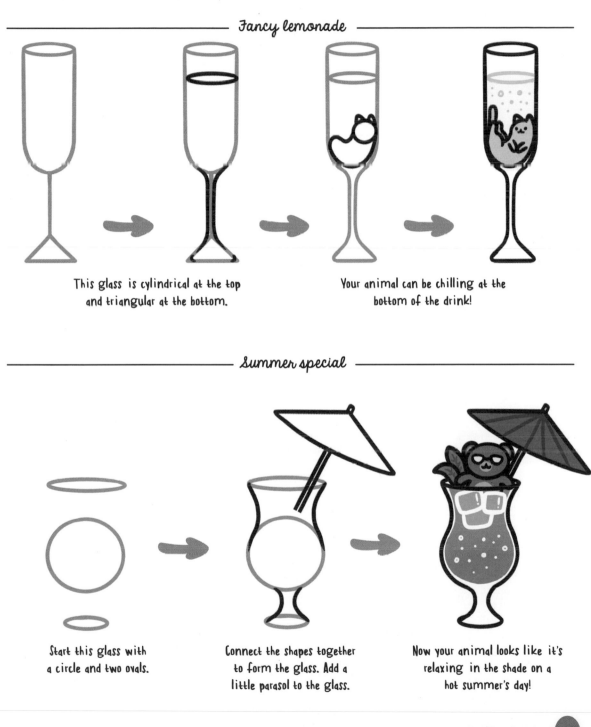

This glass is cylindrical at the top
and triangular at the bottom.

Your animal can be chilling at the
bottom of the drink!

Summer special

Start this glass with
a circle and two ovals.

Connect the shapes together
to form the glass. Add a
little parasol to the glass.

Now your animal looks like it's
relaxing in the shade on a
hot summer's day!

CREDITS

AUTHOR ACKNOWLEDGMENTS

Kenny, thank you for being by my side when I needed another hand.

PICTURE CREDITS

Quarto would like to thank the following for supplying images for inclusion in this book:

Oliver Hoffmann/Shutterstock.com; nikiteev_konstantin/Shutterstock.com; Sereda Serhii/Shutterstock.com.

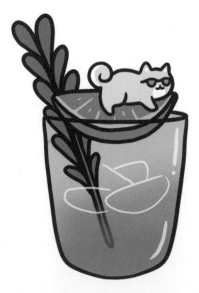